A. Hyatt Mayor:

SELECTED WRITINGS AND A BIBLIOGRAPHY

A. Hyatt Mayor, 1969. Photograph by Waintrob/Budd.

A. Hyatt Mayor:

SELECTED WRITINGS
AND A BIBLIOGRAPHY

The Metropolitan Museum of Art, New York

PUBLISHED BY

The Metropolitan Museum of Art, New York
Bradford D. Kelleher, Publisher
John P. O'Neill, Editor in Chief
Polly Cone, Editor
Peter Oldenburg, Designer

LIBRARY OF CONGRESS CATALOGING IN PUBLICATION DATA

Mayor, A. Hyatt (Alpheus Hyatt), 1901–1980.
 A. Hyatt Mayor: selected writings and a bibliography.

 Bibliography: p.
 1. Art—Addresses, essays, lectures. I. Title.
N7445.2.M29 1983 700 83-687
ISBN 0-87099-332-1

Contents

THIS PUBLICATION is made possible in part through generous gifts of funds from members of The Grolier Club of New York and many other friends of the late A. Hyatt Mayor and the Department of Prints and Photographs, The Metropolitan Museum of Art.

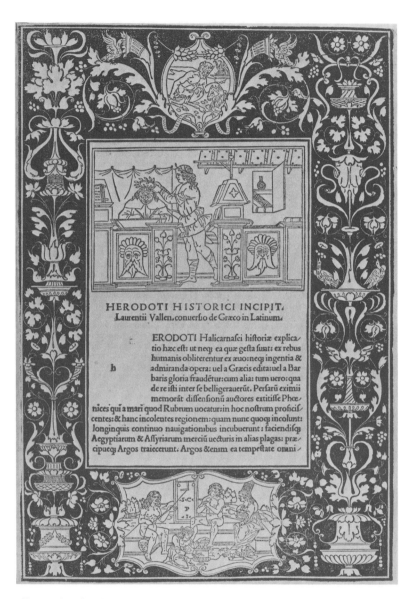

"The Historian Crowned" and, possibly, "Hercules Choosing Between Ease and Effort." Woodcuts in Herodotus, *Historiae*. Venice (Gregoriis), 1494.

Purchase, Jacob H. Schiff Bequest, 1922 (22.72.2).

Foreword

IT WAS ALMOST impossible to remember after Hyatt Mayor retired as curator of prints in 1966 that he was no longer fair game for every question that turned up, every request for direction, and every problem of translation (from Latin, Greek, French, Italian, German, or Spanish, including their sixteenth- to eighteenth-century variations). He had a carrel in the Library, but he continued to do most of his reading and writing in the Print Department. Of course the prints and illustrated books in the Print Room attracted him, and a corner of anyone's table there suited him better than a cell. And, because he was in the Print Department every day, as he had always been except when he was off lecturing, he continued to be imposed upon constantly, not only by the staff, but by people from all over who "just wanted to ask him for a small favor."

A gentleman with brains and manners of the kind not learned from a book, but out of consideration for other people, Hyatt not only went out of his way to be helpful, but also took pains never to take the edge off someone else's special enthusiasm, no matter how peculiar it might appear in the academic world. An intelligent report on beautifully designed and printed tissue wrappers for oranges could entertain him a great deal more than a student's rapture in repeating in English everything about Dürer learned from German texts. And besides, he had nothing but laughter for the pompous and pretentious.

9

Ordinarily he did things with as little fuss as possible, but, devoted to the theater as he was, he could make a verbal production with great panache out of any given situation if he cared to bother. There were times when, feeling he must educate his staff, he visibly stepped onstage to charm us into learning something. He was always willing to share his knowledge, and his writings and lectures were full of throwaways, which, if picked up by his audience, could lead to new books, exhibitions, or dissertations; he hadn't nearly enough time to pursue every idea that interested him.

As a New Englander he enjoyed finding and buying prints and books at the bottom of the market, never being tempted to spend all his purchase funds on one or two expensive prints, especially if impressions were to be found in many other collections. Instead he sought the unknown, the unusual, and the inexpensive, if one may temporarily put aside taste and beauty, which, if he did not talk about them, were always present in his mind. He was proud of acquiring a tiny book printed in Turin in 1681 on the patterns of snowflakes and another printed in Venice in 1569 showing the brands of the Italian owners of thoroughbred horses. His ingenuity in finding treasures of this sort was of extreme importance for the Museum's collection, since his predecessor, William M. Ivins, Jr., the first curator of prints at the Metropolitan Museum, had already acquired an impressive collection of masterpieces from across the centuries. Hyatt not only filled the lacunae, but chose to develop a few into major parts of the collection.

Although he used to laugh about a family attic that contained a box labeled "String Too Short to Save," he hated waste and seemed never to throw away papers of any kind. At one point he brought to the Museum from his personal mail every business envelope with a transparent window so that a large collection of decorated initial letters (one-inch printed squares) that had come to us snipped from sixteenth-century books could easily

be sorted. When this project was finished, the extra envelopes were slit open all the way around for scratch paper that he kept in his coat pocket along with pencils too short for the rest of us to write with. Ideas for gallery labels and even paragraphs for his next manuscript were often scribbled on the insides and backs of those envelopes; his staff learned never to throw out a scrap of paper.

He liked to do things with his hands, loving tools and labor-saving devices of all kinds. He really read the texts of early machinery books—Besson (1569), Ramelli (1588), and Zonca (1607), for example—and wanted to know the how of everything. If he undertook to explain techniques—of printmaking or anything else—he did it in a reduced-to-basics fashion of extreme lucidity without trade jargon.

By the time Hyatt succeeded Ivins in 1946, he had developed a genius for writing essays and putting up exhibitions that presented prints as magic windows on history and human life. The "chats" he prepared as exhibition labels are preserved in the department today as carefully as precious prints, for these astringent little texts contain pretty much all that is worth knowing about a particular picture.

Hyatt seemed to accomplish everything with the utmost ease, but he one day confessed, out of sympathy for a junior writer, that he wrestled day and night to perfect the texts of those picture labels, many of which later turned up as paragraphs in *Prints & People: A Social History of Printed Pictures* (1971). He was certain of where his energy was well spent.

Once, the power that was in the Metropolitan Museum had a tantrum and issued a decree that irritated curators. Some immediately protested and argued, thereafter finding themselves living in the beam of a high-powered searchlight. But not Hyatt, who, after a short delay, proceeded quietly and serenely to do as he thought best; he was like beach grass—prudently lying flat when the wind blew, but staying right where it wanted to grow.

He always said that when he retired he would at last find time to write, but obviously he never bothered to tally the two hundred fifteen articles and reviews, calendars and forewords, and the nine books he published. It is through his writings that Hyatt Mayor continues to enlighten and delight, spiriting us with him across the centuries, pausing to gaze at printed pictures with sympathy and wonder.

JANET S. BYRNE
COLTA IVES
MARY L. MYERS

Curators
Department of Prints and Photographs
The Metropolitan Museum of Art

A. Hyatt Mayor

/————————————————————————————/

THE ESSAYS collected here echo the mercurial jet of Hyatt
Mayor's mind, while, alas, giving only a faint reflection of the
enchantment it cast when his ideas were still words in his
mouth. He was a rousing informal lecturer, but his personal
conversation had its dash in a breadth and depth that cannot be
recaptured. His talk was the very essence of "conversation" in
the tradition of Whistler, Wilde, and Beerbohm. It was never
that he delivered little orations; his best remarks were apo-
thegms that had the delayed but lasting effect of synthesizing—
crystalizing—one's consideration.

Hyatt had genuine gifts as a mimic—almost those of a ven-
triloquist—because, while his tone was idiosyncratic, the words
were impersonally delivered, as if with no prejudice. The exact-
ness of his accent in Mediterranean languages was phenomenal;
the poet St. John Perse claimed that Hyatt was the only Ameri-
can who spoke classic French, which Diderot or Voltaire would
have taken for native. It was not only that he was a rigorously
trained classical scholar, that Greek and Latin were familiar
vocabularies, but that Attic or Roman brevity and elision shaped
his own rhetoric.

Hyatt was the embodiment of a small-scale artillery, charged
with iron and irony in baby-tiger velvet paws. Who but he
could have quietly marked a eupeptic, P.R.-type curator as
"that heartless cherub"? He declared an overpriced early Monet
landscape his museum bought "a four-color poster—come to
the beautiful Alpes Maritimes." In Hyatt's mind, the painter
André Derain, who for a time was ranked with Matisse and Pi-
casso, possessed "a weary mastery."

13

In person Hyatt appeared a trim monochromatic miniature, but when I first met him around 1930, I learned from a classmate with what equanimity he'd taken a punch in the jaw—and with what nonchalance he'd returned it. Yet, when he referred to physical suffering, even his own threatening blindness, he borrowed the detached tone of his great-grandfather, who worked with Edison on developing telephone and telegraph. He lacked an arresting physical presence, yet Hyatt had a lingering grace that was memorable. Once he came to visit us when we rented a coast-guard cabin at Lone Hill on Fire Island. One brilliant day he surprised us, uninvited and unannounced; he was dressed in shorts only and was without baggage. Past forty, he had a boy's body, and breasted the breakers like a dolphin. He stayed for lunch and then abruptly vanished as breathlessly as he had come. It was his cool gaiety that was so touching. A Frenchman we both knew said Hyatt had that transcendent, dispassionate joy that he had observed only in the monks of the Abbey of Solesmes. But Hyatt never affected youthfulness. Ageless himself, he was well aware of that deliberate, prepossessing immaturity that taints so much American life and art.

I recall his scanning the work of a young artist who had greedily assimilated the more salable styles of a half-dozen School of Paris painters. Naturally the boy had been recommended as a genius by a generous patron of the Print Room. "My, my," Hyatt sighed, "Next stop, Madison Avenue." With only a trace of acid, he described a professional charmer whose chief talent was for dining out: "Yes. He's a real genius for pleasing older men." One of his favored quotations (he was a walking anthology) was borrowed from Ernst Robert Curtius, a considerable influence in our early thirties: "*Der Knabe ist der Tod.*"

Hyatt was born in Gloucester, Massachusetts, on June 28, 1901. He graduated with honors in modern languages from Princeton in 1922 and promptly began teaching art history at Vassar. In 1926 he was a student at the American School of Classical Studies in Athens, inspecting sites and digs, ancient and Byzantine, all over Greece. In 1927 he was a Rhodes

A. HYATT MAYOR

Scholar at Christchurch, Oxford, taking his B. Litt. along with Wystan Auden. In 1927 he lectured under Richard Boleslavsky at the American Laboratory Theater, where he performed minor roles efficiently. In 1932 he joined the staff of the Metropolitan Museum as protégé of William M. Ivins, Jr., his mentor and model. In 1946 he succeeded Ivins as curator of the Print Room.

He felt then that he had entered something approaching a monastery—at least philosophically—and even viewed it with some regret. A stoic schedule precluded much free activity except with his mind. Though he was a sturdy swimmer, a promising actor, a possible poet or novelist, he turned to the Museum's collections; their augmentation and exposition became his field of daring. He retired, if one can so call it, in 1966, but retained his cubicle in the stacks, where he was encouraged to do much of his best writing. Unshackled from administration, he was constantly sought after by the organizers of world tours on which he acted as winning docent, having prepared guidebook chalk talks based on Homer and Herodotus. From 1955, for a quarter of a century, he served as president of the Hispanic Society and superintended refurbishing a great, often unvisited collection of Iberian art. From 1969 he was an adjunct professor of art at New York University. He died in Manhattan on February 28, 1980.

Hyatt had been too young for the First World War; too old for the Second. He came of age in our era's second decade, lucky enough to have touched at first hand in Princeton, Athens, Florence, and Oxford the grand Victorian and Edwardian intellectual powers that were then still vocal. Christian Gauss of Princeton gave him the polymath attitude that was also imparted to Edmund Wilson, who, like Hyatt, handled a hungry intelligence with flexible, omniverous mastery over much disparate material. Hyatt possessed no less energy or discipline in languages or ideas, but, unlike Wilson, he found the visible world the most adamant. He never saw himself as a professional art historian, and, while he received tolerant, amused, even ad-

miring attention from more famous members in the field, he gloried in his role as expert amateur. He considered "art" an idiosyncratic drama or sport—an aspect of potentially divine theater, in which he cast himself as prompter, member of a band of *comédiens*. Classical actors are not clowns, but by the assumption of masks, interpret notions satiric, tragic, or lyric. Raymond Chandler, master of Philip Marlowe, a "popular" detective and once a pupil of Dulwich, London's "College of God's Gift," wrote that a "classical education saves you from being fooled by pretentiousness."

Unlike others, Hyatt never explored the arena of haute vulgarization, by which coffee-table books and "educational" broadcasts charm a public Nietzsche knew as "the educated rabble." The self-appreciative veneer of mandarin taste trivializes art. It was no accident that Hyatt built up monumental collections of basic materials by which genuine taste is formed and without which art history has few tools. The Met's Print Room has one of the half-dozen greatest accumulations of graphic treasure, inaugurated by William Ivins, quadrupled by Hyatt Mayor. These include treatises and prints on anatomy and perspective as well as fête books, trade cards, children's books, and such ephemera as valentines. Hyatt secured the legitimate category for photography, collecting Julia Margaret Cameron long before trendier enthusiasts did. In a sense, to him all art was "modern," since he understood its place at its inception and its chance accumulation of subsequent reputations. For Hyatt the past could not die; he knew it was an endless procession, part ceremonial, part circus parade. He could worry the greedy or half-instructed with cool verdicts on questionable *trouvailles*; when he was brought one more Tiepelesque sketch, one more Impressionist blur, one more fake Rodin watercolor, he could smile: "Ah, very nice. Of custodial interest." And he knew well how to deal with dealers. One particular entrepreneur had a cellar full of the kind of treasure—priced preposterously—he knew Hyatt would want to buy. Hyatt waited a decade for death to do his work. "Undertaking," he laughed, "is a big part of

A. HYATT MAYOR

this job." But, too, there were many generous offerings from dealers who prized his selfless advice and his passion.

Prints & People: A Social History of Printed Pictures, first published by the Met in 1971, now available as a handsome paperback, rests as a solid monument, unique for its coverage and piquancy. It is Hyatt's personal vision through a lens that was both opera glass and microscope. Most of the writing he produced fulfilled the needs of a current exhibition, or described a recent haul, or drew attention to something neglected or unfamiliar. One looks in vain for a single page of self-indulgent appreciation to betray an "exquisite sensibility"—solipsism at its most expendable.

I vividly recall a conversation with Hyatt in 1930, in which he described his experience of Greece, which ran quite counter to my own clichés of received ideas from black-and-white photographs and famous rhetoric. The Parthenon was not white-plaster marble, but honey colored from iron in its stone. Once he had seen it along the length of the porch after heavy rain, with corrective entasis in all its curves. He had passed Sunium by sea, at night. The few standing columns were almost invisible, since, in shadow, they had assumed the identical value of sky, until only a thin line at their edge, hit by moonlight, penciled them as he passed. Part of the pediment, centuries ago, had rolled down the cliff; drums from broken columns had long been used as galley-ballast; what were left lay still for the Aegean to lap. Hyatt was present at the uncovering of a tomb whose interior walls had been painted, possibly by Polygnotus; when he went back six months later, this had been let powder away. So he thought of writing a book to be called *Thanatos*, but the "death" of the title was not of Periclean Athens, but rather the mortuary attitude of contemporary archaeology, which uncovered sites not to vivify, but embalm and further inter the relics of potential history. Hyatt had good photographs of the twin pediments of the temple of Zeus at Olympia. He analyzed the determination of design for placement of the sculptured figures —how one was static, balancing the other, which was kinetic;

rest against movement, the scales of order. Such generalization was familiar enough after Winckelmann, but to me it came as revelation, not alone of a specific site in a particular culture, but as an attitude toward analysis in art history; he taught one, by precision and dispassionate warmth, how to look, scan, and see.

His pictorial calendars—anthologies of wonderful observations and quotations—were far more than omnium-gatherums. He chose the very most revelatory remarks from those who saw a building, a garden, a room, at its inauguration. The freshness his captions restored to the images was the product of a wizard's instinct for the maker's intention.

His work was interspersed with brilliant asides on such things as the effect of the Argand lamp on domestic illumination and stage lighting; the influence of the metal tube for paints on landscape painting; the supremacy of French haute couture commencing with transplanted Medici taste at Fontainebleau; Napoleon's use of spare parts for artillery as it affected the gilt-bronze ornaments on furniture of the Directoire and Empire. The exhibitions Hyatt arranged, illustrated by the marvels he supervised, were graced with labels written in the manner of an offbeat X-ray, searching for dimension, and finding it. He was a rigorous popularizer, a realist setting in focus what might have been before matters were obscured by overlays of "restoration" or "interpretation."

For Hyatt "taste" was a savoring of comestibles. Bad taste was not a minor disease, like a bad cold, but an attitude; good-bad taste was represented by the thyroidal fruitiness of Bellange or the kodachromatic overkill of Maxfield Parrish. Hyatt delighted in the myriad ways history summons fantasy—how a particular vision arouses a special response at a given time. He was well equipped to illustrate any trend or movement in art's history. He was quite ready when English painters, decorators, and illustrators of the second half of the nineteenth century emerged from Victorian opprobrium. For years he'd been amassing trade catalogues, builder's manuals, and gutta-percha bindings like a pack rat.

A. HYATT MAYOR

Cocteau said that the main concern of the artist (and art critic) is "a rehabilitation of the commonplace." This elitist philosophy always served as a battle cry for "modern art." Hyatt's own eye belonged to poet and professor. As aristocratic popularizer, he was a paradox. The patrician expert embraced a median vernacular in habit and manner. He was far from being a puritan; he was unshockable. He made nice references to the illustrations of Aretino or de Sade compared to the schematic pornography of the Orient. His forte was not the novel or the exotic, but the concrete expression. The everyday was his caviar.

In a 1952 study of the handling of mythic symbols, he compared Michelangelo's physical abstractions on the Sistine ceiling to Pieter Brueghel's realism. We are inspecting Jonah and the whale:

> But Bruegel shows no [human] figures at all. All hands are below decks while the ship wallows in the thick soup of a North Sea squall. This is not just any kind of storm anywhere. It is the particular kind of storm that Bruegel must often have watched from the shore of Antwerp. Even in rendering a scene that is almost bound to be generalized he managed to tie it down to a specific locality that he knew at home.

Hyatt served with me as editor of *Hound & Horn*, a "cultural" quarterly published from 1927 to 1934. His presence was an important philosophical balance, since he offset a tendentiously rigid tone we were prone to take in order to assure our academic elders and betters that, despite avant-garde leanings, we were housebroken and right-minded. Richard P. Blackmur, our magisterial, ultimately prestigious colleague, was the opposite of Hyatt—physically and metaphysically. At our editorial conferences, against Blackmur's hair-splitting ratiocination, Hyatt shone as paladin of the colloquial and quotidian. He was tolerant but sly, humanist and generalist against an eventual depressing takeover by Neo-Humanists, Southern Agrarians, and Trotskyites.

The first major exhibition (and catalogue) that Hyatt turned his hand to after he joined the Met's Print Room was the land-

mark *Life in America*, held during the 1939 World's Fair. Here he established his manner of editing by juxtaposition, a glancing focus with many facets. There followed many shows, big and little: *Art and Anatomy* (1953); *Life in Versailles* (1956); *The Camera Out of Doors* (1959); and *Rowlandson's England* (1962). Each of these could have been turned into a lasting monograph or coffee-table blockbuster. However, the precise format of presentation, framing, and notation, the drama of actual objects in their quintessential presence almost defied permanence and recalled the evanescence of butterfly wings.

Hyatt's profession was involved in conservation and salvage. He was destined to try to save works of irreplaceable art against time and all its hazards, physical and political. Objects survive plague, wars, and human carelessness or hatred, almost with a life and continuity of their own. How much vaster is the mass of what's lost than what, ultimately, gets itself looked at. The thought of Hyatt squirreling away plates of English and American coach designs, Biedermeier furniture, catalogues of farm machinery and electroliers with as much care and energy as the sacred prints of Dürer and Rembrandt gives one pause. In his judgments of what was "important" there was an unstated moral criterion. To be sure, not everything was equally valuable, but everything did, indeed, have its value; that realization dignified a huge range of fantasy and fashion.

Hyatt's personal communications carried indelible finesse. He often sent friends postcards with quotations referring to their peculiar interests. Here is one culled from *Travels through the Middle Settlements in 1759 and 1760*, by one Andrew Burnaby:

> In Virginia towards the close of an evening, when the company are pretty well tired with country dances, it is usual to dance *jigg;* a practice borrowed, I am informed, from the Negroes. These dances are without method or regularity; a gentleman and lady stand up, and dance about the room, one of them retiring, the other pursuing, then perhaps meeting, in an irregular fantastical manner. . . .

A. HYATT MAYOR

In 1951, when George Balanchine first made his recension of the second act of Lev Ivanov's choreography for "Swan Lake," he was castigated for its conciseness, its lack of swan wings, its omission of the cygnet quartet, its absence of "authenticity." But Hyatt wrote:

> Virginia and I saw "Swan Lake" on Sunday. It was one of the few breathless moments of all my theater-going. I had thought that, now at fifty, I could no longer feel what I had felt in my adolescence, but this "Swan Lake" expanded my heart and blurred my eyes with tears. It gives all that romantic ballet can give, wrapped up in one package. Its sixty years of cooking at last have come to a boil. I have never seen a large number of people move on the stage with such expressive decision. I have never seen dancing achieve such a measure of *"luxe, ordre et beauté."* What a triumph!

In 1976 *Print Review*, the splendidly edited and produced journal of the Pratt Graphics Center, included a tribute to Hyatt by Colin Eisler, titled "A Teacher of Enchantment." An excerpt reads:

> Hyatt always learns from laughter and teaches with it. His speech, punctuated with humor, bridges the divide between past and present, between word and image. Humor permits quantum leaps into the past, those sudden acts of sympathetic magic that make the inexplicable happen—great teaching. Tragedy and awe don't make for learning—both beyond the lesson and *avant la lettre.* Always sharing, never lecturing, Hyatt Mayor's teaching is a constant process of listening and responding to past or recent achievement. In terms of his love for festivities, he is always setting off fireworks that illuminate art, its makers and collectors. Never seen as another brick in the Babel of *Kunstgeschichte*, Hyatt understands and re-presents the work of art, sounding it out as a souvenir or dream, protest, loveletter or laundry list, rejecting all scholarly rhetoric that obscures particularity. His talks are constructed like the very best Parisian roasts—whose butchers slip pistachios into the veal—providing oblique, piquant perspectives, relishing the flavor of the past.

However grateful and generous Hyatt's colleagues, friends, and students are, perhaps it remains for a poet to put into words

exemplifying the spirit of his life and work, what it was he saw, and how he saw it. We are standing with Wystan Auden in the Musée des Beaux-Arts, Brussels, looking at Brueghel's *Fall of Icarus*:

> About suffering they are never wrong,
> The Old Masters: how well they understood
> Its human position; how it takes place
> While someone else is eating or opening a window or
> just walking dully along;
> How, when the aged are reverently, passionately waiting
> For the miraculous birth, there always must be
> Children who did not specially want it to happen, skating
> On a pond at the edge of the wood:
> They never forgot
> That even the dreadful martyrdom must run its course
> Anyhow in a corner, some untidy spot
> Where the dogs go on with their doggy life and the
> torturer's horse
> Scratches its innocent behind on a tree.
>
> In Brueghel's *Icarus*, for instance; how everything turns away
> Quite leisurely from the disaster; the ploughman may
> Have heard the splash, the forsaken cry,
> But for him it was not an important failure; the sun shone
> As it had to on the white legs disappearing into the green
> Water; and the expensive delicate ship that must have seen
> Something amazing, a boy falling out of the sky,
> Had somewhere to get to and sailed calmly on.

<div align="right">Lincoln Kirstein</div>

American Letter

Formes 12

FEBRUARY 1931: 35–36

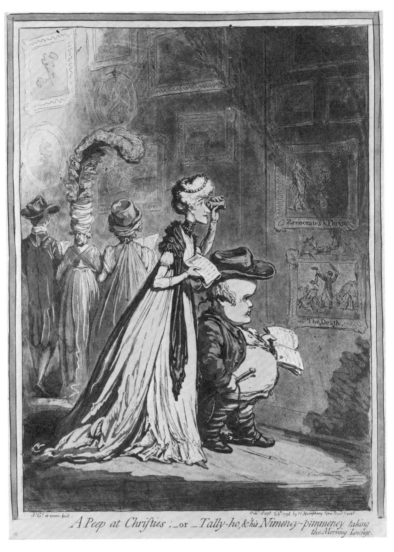

James Gillray. *A Peep at Christies; or Tally-Ho and His Nimeney-Pimmeney Taking the Morning Lounge.* Etching and aquatint, 1796.

Gift of Susan Biebel in memory of Franklin M. Biebel, 1975 (1975.558.1).

F
OR THIS LETTER I have thought that it might interest a Paris public to hear about auctions here in New York, since they differ greatly from auctions in Paris. I passed through the Hôtel Drouot only once, and brought away a confused recollection of dingy rooms cluttered with rummage, of dust on board floors, dust on walls and windows and electric light bulbs, of crowds and of cries through which I could neither hear the auctioneer nor glimpse what he was selling. I may have happened in on an auction of solid Holbeins and Titians, but I suspect that they were really selling stained washstands and crazy wheel chairs like the ones piled in corners behind me. I went away as doubtful of having really been at the famous Hôtel Drouot as Fabrice del Dongo was of having been at the Battle of Waterloo.

Here in New York auctions are less picturesque. There are various vague auction rooms for disposing of the furniture and the bindings (one can hardly call them books) of deceased actresses, but there is only one really great auction house, the American Art Association, which has a whole building to itself on 57th Street among all the art galleries. The show rooms are on the top floor, to which you are taken in lifts as roomy as those that go to the top balconies at the Opera.

These show rooms might remind one of a museum were it not for the luxury of carpets, the haphazard collections in the show cases, and the smart assemblies that meet there around tea time. The spectacular sales take place in the evening, in a small theatre like those that German princes used to attach to their palaces, complete with red plush seats, chandelier, balcony, and a proscenium in white and gold. The great auctions gather a "house" as brilliant as first nights at the Opera, although you might not think so if you came in early and found all the best seats in the middle of the parterre occupied by ragamuffins

and newsboys. The unimportant onlookers arrive early in the hopes of getting places. There are generally more women than men, and the balcony fills with possible countesses wearing unlikely hair, who lean over the gilt balustrade and watch through pearl opera glasses.

Whenever an usher recognizes, among the late comers in evening-clothes, some important collector with his wife, or better, he shows them to the center seats, ousting the little boys, who are then free to run away and collect their tip from the office downstairs. The auctioneer mounts into his pulpit with the invested dignity of a preacher, reads the conditions of the sale as though they were the Gospel lesson for the day; then the crimson curtains part and the sale begins.

The empty stage is hung in crimson plush. In the middle stands a plush pedestal like an altar. A negro, as sleek as those you sometimes see in Venetian Adorations of the Magi, enters from the right, dressed in uniform. He carries, as reverently as though it were a relic of the True Cross, a Renaissance bronze or perhaps an urn of Syrian glass, lays it on the altar where the lights focus, and withdraws. Uniformed attendants stand like beadles among the audience and sing out the bids as the bidders raise their pencils or lorgnettes. When the gavil falls, an attendant enters the stage from the left and retires with the sold relic, while the next one is being brought on from the right. The whole audience busily writes down the price with a knowing bustle that means nothing, since they leave almost all their carefully inscribed catalogues behind, like theatre programs. Large objects, such as thrones, bonheurs du jour, triptychs or cassoni, are trundled out on crimson plush floats, like those that carry the images of the Passion for Corpus Christi processions in Spain. These relics of better times pass by tremblingly, stumbling along a Via Dolorosa as though they really suffered at being clapper clawed by the vulgar, and sold at so much per pound of wood, stone or canvas.

Since these audiences have no knowledge to give them courage, nor taste to inspire them, they bid much less than Hôtel

A. HYATT MAYOR

Drouot audiences for small objects such as good pictures of uncertain attribution, or drawings by lesser known artists. The things with clamorous names fetch such immense prices because a few of the big dealers are struggling to secure them for mesmerized clients. The great sales often have a sordid touch of drama. Last year Sir Joseph Duveen came in person in the middle of the Judge Gary sale to bid on three gold Isfahan rugs, one of them the largest known, I believe. Each rug was considered worthy of a whole act in the comedy, so for each one the curtains closed, parted, and closed again. Sir Joseph was not in evening clothes, and sat looking at nothing in particular, but every time he crooked his little finger, the bid jumped $5,000. After spending, in ten minutes or so, more than $200,000 for the three gold rugs, he rose from his seat with elaborate unconcern, flecked an imaginary dust speck from his cuff, and strolled out as though he had just bought a soda. The crowd burst into abject applause.

The spectacular works of art have continued to bring great prices all this year, in spite of the depression. At the Monell sale early in December a Rembrandt portrait of a Rabbi (not, in my opinion, very good) fetched $75,000, a Reynolds of Lady Mary O'Brien $31,000, and a Turner of the Giudecca $85,000. The Turner was bought back into England, to the satisfaction of both countries. When these same pictures were auctioned at the Yerkes sale in 1910 they fetched only about two thirds as much. A Houdon bust at the recent Comtesse de la Béraudière sale brought $80,000. The interesting sales have been, however, very few this year because of the widespread timidity.

Nor have there been many interesting exhibitions since my first letter. I will speak of the Guelf Treasure later, for that is something rather apart. The Weyhe Gallery's exhibition of Atget photographs was such a success that it had to be prolonged.

I do not know if Atget appeals as strongly to Parisians as he does to us, although I think he might, for his Paris was Baudelaire's Paris, "où le spectre en plein jour accroche le passant."

Utrillo used many of these photographs to save himself the bother of painting on the spot. Atget, however, had a sharper sense of solitude and a more original eye than Utrillo. It seems to have been more or less of a revelation to professional photographers that Atget's photographs should so abound in light.

Much of Atget's work will not be properly "ripe" until 1900 becomes as romantic as 1860 is in process of becoming, until Atget's costumes become as strange as Nadar's. Then his spells will really get to work.

Translation

Hound & Horn 5,1

OCTOBER–DECEMBER 1931: 5–17

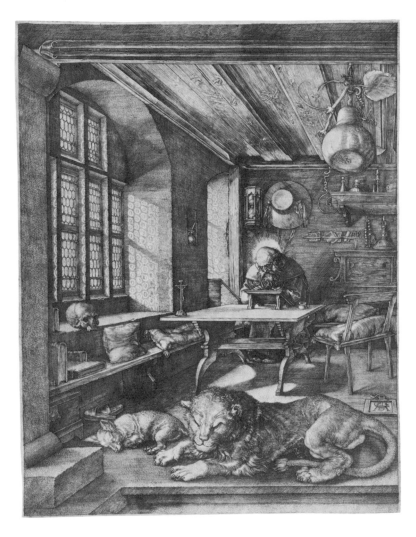

Albrecht Dürer. *Saint Jerome in His Study*. Engraving, 1514.
Fletcher Fund, 1919 (19.73.68).

For Ezra Pound: *il santo atleta,*
benigno ai suoi, ed ai nemici crudo

"Methinks I come like a Malefactor, to make a speech upon
the Gallows, and to warn all Poets, by my sad example, from the
sacrilege of translating Virgil."

Dryden's Preface to *Sylvae*.

Most people, even people who admire the English
Bible, consider translators as hack writers pressed for cash, and
their translations as nothing but gawky substitutes for the
originals. This is not always so.

Poe, for instance, speaks French more readily than English,
as any comparison of his writing with Baudelaire's translation
will show. Notice how the end of the following passage, the de-
layed summing up, rings out so much more triumphantly in
French than it does in English, even though translated word
for word:

> Moreover, although it was stated by *L'Etoile* that the corpse
> was reinterred at the public expense, that an advantageous offer
> of private sepulture was absolutely declined by the family, and
> that no member of the family attended the ceremonial:—al-
> though, I say, all this was asserted by *L'Etoile* in furtherance of
> the impression it designed to convey—yet *all* this was satisfac-
> torily disproved.

> En outre, bien que L'Étoile affirme que le corps a été réen-
> terré aux frais de l'État—qu'une offre avantageuse de sépulture
> particulière a été absolument repoussée par la famille—et
> qu'aucun membre de la famille n'assistait à la cérémonie—bien
> que l'Étoile, dis-je, affirme tout cela pour corroborer l'impres-
> sion qu'elle cherche à produire,—*tout cela* a été victorieusement
> réfuté.

Even in Poe's best writing, in his descriptions, Baudelaire often made something more dense, more inevitable. Notice the sound of *drap mortuaire* in the following:

> Some few ottomans and golden candelabra, of Eastern figure, were in various stations about; and there was the couch, too—the bridal couch—of an Indian model, and low, and sculptured of solid ebony, with a pall-like canopy above.

> Quelques rares ottomanes et des candélabres d'une forme orientale occupaient différents endroits, et le lit aussi,—le lit nuptiale,—était dans le style indien,—bas, sculpté in bois d'ébène massif, et surmonté d'un baldaquin qui avait l'air d'un drap mortuaire.

Poe's case may be a special one, since he seems so often, while writing English, to be thinking in French. At any rate, Baudelaire's translation often has an air of restoring Poe to his mother tongue, just as *Gil Blas* was "restored" by being translated into Spanish.

But apart from intrinsic merit, translations often help even the greatest artists to their creations. It is a classroom commonplace to compare passages in Shakespeare with North's *Plutarch*, but little attention is paid to the additions that Shakespeare made to North. It may be interesting to give a genealogy of one of Shakespeare's most quoted passages. The words in *italics* are those that each writer has *added* to his predecessor. They show how Amyot made Plutarch more loquacious, and North more precise:[1]

> AMYOT: Elle n'en daigna autrement s'advancer, sinon que de se mettre sur le fleuve Cydnus dedans un bateau, dont la pouppe estoit d'or, les voiles de pourpre, les rames d'argent, que l'on manioit au son et à la cadence d'une musique de flustes, haulbois, cythres, *violes et autres telz instrumens dont on jouoit dedans*. Et au reste, *quant à sa personne*, elle estoit couchée dessoubs un pavillon d'or tissu, vestue *et accoustrée toute en la sorte* que lon peinct *ordinairement* Venus, et auprès d'elle d'un costé et d'autre de *beaux petits* enfans *habillez ne plus ne moins que les*

1. For an extended comparison of Amyot and North, see F. O. Matthiessen's excellent study: *Translation, an Elizabethan Art*, Harvard University Press, 1931.

peintres ont accoustumé de portraire les Amours, avec des esvan-
taux *en leurs mains*, dont ils l'esventoyent.

NORTH: She mocked Antonius so much, that she disdained
to set forward otherwise, but to take her Barge in the River of
Cydnus; the Poope whereof was of Gold, the Sailes of Purple,
the Owers of Siluer, which kept stroke *in rowing* after the sounde
of Musicke of Flutes, Howboys, Citherns, Violls, and such
other instruments as they played upon *in the Barge*. And now
for the person of her selfe: she was layed under a Pauilion of
Cloth of Gold of Tissue, apparelled and attired like the goddesse
Venus, commonly drawen in *Picture :* and hard by her, on either
hand of her, pretie *faire* Boyes apparelled as Painters doe set
forth *god Cupid*, with *litle* Fannes in their hands, with the which
they fanned *wind upon her.*

SHAKESPEARE:
The Barge *she sat in, like a burnisht Throne*
Burnt on the water ; The Poope was *beaten* Gold,
Purple the Sailes: *and so perfumed that*
The Windes were Loue-sicke
With them. The Owers were Siluer,
Which to the tune of Flutes kept stroke, *and made*
The water which they beate, to follow faster ;
As amorous of their strokes. For her owne person,
It beggerd all discription, she did lye
In her Pauilion, cloth of Gold, of Tissue,
O're-picturing that Venus, *where we see*
The fancie out-worke Nature. On each side her,
Stood pretty *Dimpled* Boyes, like *smiling* Cupids,
With *diuers colour'd* Fannes whose winde *did seeme,*
To gloue the delicate cheekes which they did coole,
And what they undid did.

If you read nothing but Shakespeare's additions (printed in
italics) Shakespeare looks like an own cousin to John Donne. It
is as though he took the dense matter of antiquity and charged
it with the effervescence of the metaphysical spirit, that spirit
whose workings he had dramatized long before in *Richard II.*
Plutarch was his diving board, whence he sprang off, again and
again, into the blue of his own heaven. He seems most at his
ease while paraphrasing, as though the structure of antique

rhetoric stimulated him to his freest elaborations. His original-
ity, or perhaps all originality, is not a matter of theme but of
treatment. Shakespeare works like a musician making variations
on another man's air.[2]

FOREIGN AUTHORS (especially authors in dead languages) need
translators in the same way that composers need musicians—to
quicken their hieroglyphics into sound and sense. The inter-
preter of a foreign author or piece of music should obliterate
himself in an attempt to reproduce the exact effect the author
or composer intended. I say *should*, though few do, since it takes
more reverence and historical taste than most musicians pos-
sess, more reverence and skill in English than most translators.
As Dryden said: "In such Translatours I can easily distinguish
the hand which performed the Work, but I cannot distinguish
their Poet from another." Among English translations, our
Bible has the supreme authority of reverence, knowledge of the
object and mastery of the means. Among contemporary musi-
cians, probably Wanda Landowska.

The translator's humility before his object is not to be de-
spised, for it may provide a poet with one of the few remaining
escapes from the private world, as it does for Ezra Pound in his
Cavalcanti. It *may* provide such an escape, but does not neces-
sarily do so, as Pound shows in his *Propertius*, which is a teach-
er's joke, a wink he shares with the head of the class, if any. His
Propertius is not so much a translation as a commentary whose
wit can be savored only after comparison with the original. I
know only one other translator who demands that you know his
original as thoroughly as he:—Launcelot Andrewes when he
gives, for instance: "Whom of His just wrath against sin He
brought hither, now having fulfilled all righteousness he was to
bring hence again" as the English for: "Quem deduxit iratus,
reduxit placatus."

2. North's *Plutarch* is a mine of stage business for any *régisseur* about to pro-
duce any of the Roman tragedies. The action of the scenes around the Monument
in *Antony* is especially made clearer.

A. HYATT MAYOR

Translations of contemporaries, like Urquhart's *Rabelais*, Baudelaire's *Poe*, or even such a sloppy job as Florio's *Montaigne* have something of the authority of a single mind, since both the author and the translator have read more or less the same books, take more or less the same things of their time for granted, use languages in more or less the same stage of development, and can count on addressing audiences that share these similarities. The translator of a contemporary has not only his own mind to catch his author with, but the mind of his time as well. As such a contemporary translation ages, its language acquires the authority of "dating" back to the same period as the original. An author talks out of a contemporary translation like a single head out of double tongues.

The authority of a contemporary translation is unique and irrecoverable because a work of art reveals itself "in the round" to its own time only. Later times see it by parts, and because they see it by parts, they see successive parts more sharply.

(For it is not altogether true that the greatest works of art preserve their essence for posterity only. We see far deeper than Shakespeare's contemporaries into Shakespeare's use of simile, source material, character drawing, or poetry, but we do not know him "in the round," as his audience did. Seeing him in our theatres helps, but not much, since no actor today can think fast enough to keep pace with the evolutions of his arabesque, nor can we as audience. His own audience grasped his poetry, characters, and situations as part and parcel of their own freshly developing lives, and they saw his great machinery working in the outdoor theatre and on themselves, the outdoor audience for which it was devised. Shakespeare was something much more complete than anything we can imagine when Antony for the first time said: "Unarm, Eros, the long day's task is done" into the full glare of sundown, and Charmian, in the early night, was first found trimming up Cleopatra's diadem. We miss, for one very simple thing, the eternal rhythm imposed by the westering sun, and the play of day's end on the end of his tragedies; Hamlet being carried back into the deeper dusk within

the traverse, to the far thunder of ordinance; Coriolanus shouting: "Men and lads, stain all your edges on me" in a gathering blackness slashed by torches. Electric lights and scenery are an impertinence to Shakespeare, whose words can do a trick worth twice all that—when, that is, you have live actors and a live audience. The trouble is that works of art are made for use and kept, when kept at all, for decoration. When Shakespeare is translated nowadays, he is translated as character drawing, or poetry, but never as outdoor stage machinery.)

Strictly speaking, an ancient work of art is impossible to translate because we no longer have the identical use for it, nor the identical mind to grasp it with. (But then strictly speaking, no mind can do exactly the same thing as another—not even contemporaries can play each other's music. Duke Ellington cannot play Louis Armstrong's trumpet, nor can Armstrong think in Ellington's harmonic progressions.) Translations are possible only if you allow as much approximation as there is in a musician playing some other man's music.

Because few men see much beyond what the mind of their time accustoms them to see, old translations of Greek and Latin authors gradually part company with their originals and appear as independent works of their later times. This can be illustrated by some lines (*Iliad* I, 345) from the three outstanding English translations of Homer; from Chapman, who caught Homer's adventurous energy, from Pope, who saw his swift ease (perhaps the chief thing, after all) and from Lang, who looked back on his early simplicities:—

CHAPMAN:
This speech vsd, Patroclus did the rite
His friend commanded; and brought forth Briseis from her tent;
Gaue her the heralds, and away, to th' Achiue ships they went:
She sad, and scarce for griefe, could go; her loue, all friends forsooke,
And wept for anger.

A. HYATT MAYOR

POPE:
Patroclus now th'unwilling Beauty brought;
She in soft sorrows, and in pensive thought,
Past silent, as the heralds held her hand,
And oft look'd back, slow moving o'er the strand.

LANG: So spake he, and Patroklos hearkened to his dear comrade, and led forth from the hut Briseis of the fair cheeks, and gave them her to lead away. So these twain took their way back along the Achaians' ships, and with them went the woman all unwilling.[3]

Pope cannot be read as Homer (hence the witlessness of the Nonesuch Press in using him for their bi-lingual Homer) but it is one of the finest eighteenth century poems in the classical taste. Lang and his collaborators already look almost as exclusively Victorian as Chapman is Elizabethan. Our time is ready for a fresh translation of Homer, a simple one, without archaisms (and ours will probably part company with the original for lack of dignity). To translate a concrete writer like Homer, you have to melt him down until nothing remains but his object, and then build up from that object again in the nearest English equivalent to his style. This is not easy, but still possible, whereas a writer like Horace looks to me impossible to translate, since Latin syntax is so much his inspiration and his fabric that almost nothing can be wrenched loose for use in a less inflected language. The same is true of Virgil.

A French author (Baudelaire, for instance) can often be rendered word for word and keep his meaning and tone. This you can rarely do with German, where the inflection and construction are about as complicated as simple New Testament Greek. Classic Greek is a step still further away from the genius of

3. Lang's artificial New Testament lisp, his learnedly affected awkwardness, was probably suggested to him by a remark in Arnold's admirable essay *On Translating Homer* : "The Bible is undoubtedly the grand mine of diction for the translator of Homer." But Lang's "simplicities" neither recapture Homer's clean speed, nor the Bible's grave brevity. Arnold showed how much more wisely he meant his remark in his fragment of translation from the *Iliad*, probably the truest *Iliad* in English.

English. In fact the complex brevities of Greek and Latin, their habit of making words ring by placing them rather than by selecting them, makes ancient authors very hard to coax into a language as simply inflected as English is. Sophocles, for instance, constructs his sentences like algebraic equations, wrenched apart by emphatic brackets. Yet even English words are made to ring by their place alone in the Elizabethan dramatists and preachers, who wrote to be spoken. For rendering Latin, English must become almost impossibly concise, and for Greek almost impossibly swift and limpid. Also, each Greek word rings simple and clean, while an English word remembers a millennium of Babel. The translator of Greek and Latin can hardly avoid assuming the embarrassing freedom of paraphrase.

Ancient works of art shine on after ages like stars, now brighter, now dimmer. You cannot expect to improve upon a translation made during an author's almost full visibility. For instance, eighteenth century England, with its collaboration of politics and literature, its Grecian elegance, its travelled urbanity, is sufficiently close to Augustan Rome to be able to catch the genuine flavor of many Latin and some Greek writers. The study of Cicero and Tacitus had formed an English that was admirably adapted to translating these authors. Melmoth's *Letters of Cicero*, Murphy's *Tacitus* (reprinted in the *Everyman*) and Carr's *Lucian* (Lucian, who was himself almost an eighteenth century journalist) catch more of the distinguished ease of their originals than any translations could nowadays. (It is a pity that the *Cicero* and the *Lucian* have been allowed to go out of print since the early nineteenth century.) Again, the early Renaissance was enough like late antiquity in its greed for exemplary tittle-tattle about Greek and Roman worthies to enable Amyot to bring Plutarch into French all alive. It is because Elizabethan England got into the habit of gloating over Italian murders that Philemon Holland was able to catch the full richness of Suetonius's Roman garbage. (This is another translation that deserves to be more accessible than it is in the Tudor Translations reprint of 1899.)

A. HYATT MAYOR

Before you set about translating an ancient author you must determine what kind of an audience he was addressing and how he wished to move them. Then you must look about and see if you have a similar audience that can be moved by these same things. If you have not, your translation, addressed to the void, will be an empty exercise. Did the author, for instance, set out to touch the single heart, like the New Testament, or to address the whole tribe, like the Old? The translators of the Bible worked for a congregation that needed prayers and collects for its private devotions and sermons for its public exhortations. It was this congregation, and not King James, that called our English Bible to life. The translator of a contemporary does not have to worry about an audience.

THE QUOTATIONS from Plutarch and Shakespeare have shown, if it needed showing, how important a rôle translations played in Elizabethan literature. If English is ever to have another literature (can it?) good translations would help make it possible, especially good translations from the antique, the grand mine of form. It might be useful to attempt a catalogue of the antique translations that are good enough to keep, and of those we still need to have done.

We are well supplied with the historians, since most of our translations have been made in universities. Herodotus, Thucydides, Xenophon, Livy, Tacitus and Suetonius all exist in admirably readable and accurate versions. We have more Latin authors than Greek since both the Catholic Church and the Renaissance grew up on Latin ground. Indeed, the Greeks were pretty much of a mystery even to the Romans (Tacitus, for instance, understands Tiberius like a brother, but seems a bit stumped by Nero's more Greek profligacy). The Renaissance (so much more Senecan than Sophoclean) was naturally still farther from the Greeks. Even Shakespeare's historical intuition (perhaps the sharpest there has ever been) did not get to the Greeks; *Troilus*, for instance, is simply another Roman sneer at the rickety last Greeklings. I imagine that the real Greeks have

become partly visible only in the last century, only since Fustel de Coulanges taught us not to read our modern minds into the past, since the Aegina marbles were brought to Munich in 1812, since the Acropolis maidens were unearthed and the Olympia pediments re-assembled in the 1880's. These statues help one to read even Aristotle. They will not let you mistake the "Greek balance" for an equilibrium of repose, but show it as an instant's ticklish capture, a pole vaulter poised for a camera flash in air. I might almost say that the Greek dramatists were impossible to translate before the Olympia pediments were known.

Outside the historians, I can think of no good translations of Greek prose except North's *Plutarch*, Carr's *Lucian*, and Church's readable and simple version of parts of Plato. (Jowett's Oxonian lecturing throws cold water all over Plato.) I can think of no good translations of Greek poetry, except perhaps H. D.'s crisp, but structureless, fragments; Arnold's fragment of the *Iliad*, and Pound's swift wonderful *First Canto*, of Odysseus among the dead.

And then there are the dramatists. It has been for some time the custom (a good custom) to boo on Sir Gilbert Murray for taking good clean simple Greek and charging it with garbage lugged from Swinburne. Contrary to most people, I think Jebb no better, with his petrified "poetic" jargon, his *sires*, his *guerdons*, his *doths*, and his *doth n'ts*. Jebb is dull enough to be a trot, but not exact enough to be so useful. Yeats' translation of the *Oedipus* and *Antigone* is much better than these things, but even Yeats never winds up (as Sophocles always does) to a clinch. Worst fault of all, not one of the three has any sense of the stage, any sense of English fitted to an open mouth, or of what the actor's gesture can be left to express. For instance, when Oedipus becomes inarticulate with rage at Creon, he turns to the chorus of old Thebans for justification, crying out to them: ὦ πόλισ, πόλισ, *O city, city*, a cry his gesture makes amply clear. (A stage version could probably catch the sound as well as the sense with *Thebes, Thebes*.) But our translators dilute this vividness with explanations. Both Jebb and Yeats (in the one

place I know where Yeats copies Jebb) give: "Hear him, O Thebes." Murray makes poor Oedipus fidget like the king of Lilliput: "To your King! Ho, Thebes, mine own."

As Dryden put it: "For a just Reward of their Pedantick pains, all their Translations want to be Translated, into *English*."

Cocteau's shorthand versions of Sophocles would be admirable if they did not carry a certain schoolmasterly dryness into an affectation.

Poor people like me, who have to sweat at Greek, have no resource but trots. A trot differs from a translation in having no literary independence, and should always be printed side by side with the original, since it exists simply to give foreign words more handily than a dictionary and to help disentangle the syntax. A good trot should give the exact meaning and trade connotation (nautical, medical, philosophic, etc.) of each word. Though good trots are much easier to make than good translations, they are even scarcer. The best I know, in spite of expurgations and inaccuracies, are the old Classiques Juxtalinéaires that Hachette used to bring out from about 1840 until 1890, when the schoolmasters stopped them because they made Greek and Latin too charmingly easy. The best trot in English is undoubtedly the Temple Classics *Dante*, with its almost perfect selection of notes. Locke advocated (perhaps even originated) interlinear texts in *Some Thoughts concerning Education*—(an essay which, had it been listened to, might have made the British Public School System a little less conspicuously stupid). Early in the eighteenth century John Clarke carried out Locke's theories in a delightful series of bi-lingual Latin texts. Their modern successors, the Loeb Classics, do well by their prose authors (except for their eager prudery) but render most of their poets in English verse, where literalness (a trot's only value) is impossible. A trot must be literal even where literalness makes nonsense in English. The paraphrase that makes sense should be given in a foot-note, as in the old Classiques Juxta.

It is shameful that we should have no acting translation of

any Greek dramatist, none plain and bold enough to declaim through a mask on an afternoon out of doors. Yeats has taken a good step in that direction, but even he falls below the style that Sophocles requires, geometric and terse. Yet I think that our barren English of today might be forged out into an instrument fit for Sophocles, who wilfully stripped his Greek almost as bare. He would certainly hold our attention as a constructor of melodrama, even though he might lose it by his legal quibblings. I doubt if any post-Elizabethan English could catch Aeschylus (more's the pity), but something better might be done with Euripides and Homer. I could wish for an Aristophanes with less bully beef about him than Hookham Frere's, though I doubt if our time permits that, either. We need a less luscious Petronius, something vindictive and distinguished. Our intellectuals ought to be enraged enough to take up the Roman satirists again and fling their vitriolic dirt, although I fear that our Christian habits of mind would hinder us from reaching out to their heroic sweep of bitterness and obscenity.

These tasks are not hackwork. They deserve the consideration of any modern poet.

EXCERPTS FROM
Goya's "Disasters of War"

American Magazine of Art 29

NOVEMBER 1936: 710–15

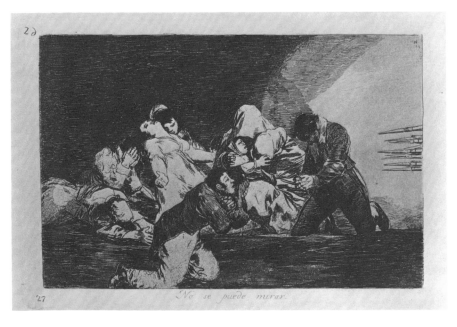

Francisco Goya. "You Can't Look." Etching and aquatint from the series *Disasters of War*, 1810–23.

Purchase, Jacob H. Schiff Bequest, 1922 (22.60.25).

MOST OF THE tropical land snails exhibited in the cases of natural history museums are dead, and stay stuck to their Latin labels, but occasionally some steamy summer will remind a still living one of its long-lost jungle home, and it will slide off its label, and once again push out its horns into the world. Some works of art are like that snail. They wait for centuries on their pedestals until a turn of time repeats some factor of their creation, and then their spirit walks forth among us, and we see our moment through a long-dead artist's eyes. Last year cobble stones were thrown in the Paris streets to shouts of "Coriolan," and the authorities stopped the run of Shakespeare's suddenly inflammatory play, which shows us our fascist-communist dilemma as vividly as Hamlet showed the nineteenth century its different dilemma.

The civil war now raging in Spain has brought Goya's "Disasters of War" to this intense second life. Through them we see deeper into the present suffering in Spain than we can through the news photographs. A century and a quarter ago Spain was the scene of the same sort of guerrilla warfare, the sniping from windows and hilltops, the groups collapsing before the firing squads, the wide pits packed with human meat and bone. Goya saw it all and made a record that sums up the atrocious scrimmage of all hand-to-hand fighting.

When Napoleon invaded Spain in the winter of 1807–8 to annex it to his fly-by-night empire, he was fiercely resisted by every man, woman, and child. Desperate individual fighting continued until Napoleon's abdication in 1814, although Wellington's British troops assumed a growing share of the effective resistance. The shock of the invasion was all the greater since the Spaniards believed their arms were still invincible, as they had been in the 1500's. Several years after the start of the Peninsular War came the "year of hunger," whose horrors are still

remembered in Spain. Communications broke down, and from September, 1811, to August, 1812, over twenty thousand people are said to have starved to death in Madrid. Only one or two of the "Disasters" can be said to represent a definite historical incident. Goya was not a news reporter, like Joseph Pennell, but a recorder of the imaginative essence of his experience.

Goya's reaction to war may probably be summed up in one word: futility. But there is no propaganda. The captions to the "Disasters" never name the French invaders who caused the War, and Goya nowhere implies: "Let there be no more such wars." His business was not with uniforms and parties, but with men and women. He did not set out to convert or to teach a lesson, but to clarify the confused first impressions of an intense experience. Although the "Disasters" have been effectively used for pacifist propaganda, Goya was anything but a propagandist. A propagandist, like Forain, strains his dramatic resources to make you change your opinions. His art consists of stage whispers and hysterics. Goya, on the other hand, devotes his attention to clarifying his intuitions of life and to organizing them into a work of art, which he offers with a take-it-or-leave-it detachment. His eye is on his work, not on his audience.

Three of the "Disasters" are dated 1810, Goya's sixty-fourth year, when he stood at the top of his artistic powers. He had been the John Singer Sargent of his place and time until the French invasion, by stopping practically all orders for portraits and decorations, concentrated his mature and undistracted energy on work done with no thought of a buyer. His country's disasters helped him to achieve the supreme masterpieces of his art.

A Gift of Prints

The Bulletin of The Metropolitan Museum of Art 32, 6

JUNE 1937: 140–43

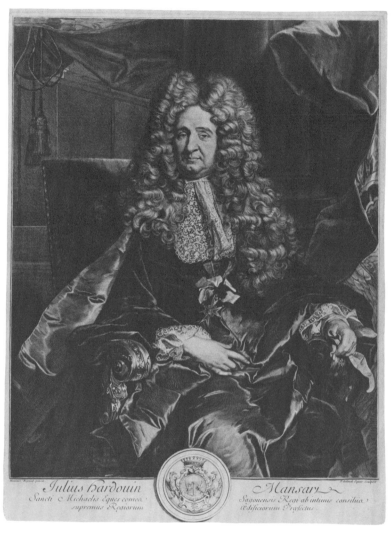

Gérard Edelinck, after Hyacinthe Rigaud. Engraved portrait of Jules Hardouin Mansart.

Gift of Edward W. Root, Elihu Root, Jr., and Mrs. Ulysses S. Grant III, 1937 (37.17.25).

As a gift from Mrs. Ulysses S. Grant, 3d, Edward W. Root, and Elihu Root, Jr., the Museum has received a group of seventy-eight prints from the collection of the late Elihu Root. The main body of this welcome gift consists of French engraved portraits of the seventeenth and eighteenth centuries.

The seventeenth century was the great age of royal authority in France. Through the policy of successive kings and their ministers the power of the Crown was gradually built up at the expense of the feudal nobility until Louis XIV was finally able to hinge the whole machinery of government on his personal decision. Admitting the nobility and the high ecclesiastics only to sinecures, he formed his state councils and chose his ministers from the *noblesse de robe*, the middle-class families which the almost hereditary profession of the law had formed into a kind of caste. The king felt safer with servants who owed their whole importance to his whim. As long as he chose, they were all-powerful, since he not only acted entirely through them but received only such news and petitions as they cared to relay. Being all-powerful, they were courted by all who had careers to make. A candidate for professional life first passed a doctor's examination in philosophy, law, theology, or medicine by defending a list of propositions in public debate. This list was printed on a broadside, often a yard long, which it was tactful to dedicate to some political bigwig, who could be still further flattered if his expensively engraved portrait appeared at the head of it. This cost the candidate as much as a debutante's coming-out party. Nanteuil contracted to furnish an edition of 2,500 copies of a thesis broadside, headed by one of his engravings, for a price whose modern equivalent would be from $10,000 to $15,000. This fashion of decorating a thesis explains why the likenesses of government officials, often ministers of finance, abound in

A Gift of Prints 49

any collection of French seventeenth-century engraved portraits. The texts have almost always been cut away in order to save space in the scrap albums of old collections.

In the group of prints which has just been given to the Museum, there is Masson's handsome big portrait of Denis Marin, minister of finance to Louis XIV, which bears a candidate's engraved dedication. The collection also contains a fine impression of Morin's etching of Augustin de Thou, president of the parliament of Paris and grandfather of the famous bibliophile and historian. Morin did a remarkable job in making a lifelike picture of a man who had been dead almost a century.

The Church as well as the State revolved in planetary obedience around the Roi Soleil, and the bishops who sanctified his authority got their share in the immortality of the engraved portrait. From Mr. Root's collection the Museum has received Masson's sensitive print of Louis Abelly, who pleased the king by writing against the hated Jansenists. There is also P. I. Drevet's portrait of Bossuet, who served royalty like a legion of angels by lavishing his oratory on the catafalques of princes, by likening Louis XIV to Solomon (in public life, of course), and by originating the definition "King, Christ, and Church are God in three names." Bossuet is shown as Rigaud painted him, smothered in the silk and ermine robes which kept the chill of cathedral stone from striking at his sedentary blood.

The artists who worked to eternalize the king's majesty also had their portraits engraved. The present collection includes Vermeulen's engraving of Joseph Roettiers, who engraved dies for the king's mint and whose family produced over a dozen medalists. There is also Van Schuppen's portrait of the battle painter Adam Frans van der Meulen, who traveled with Louis XIV on campaigns and indulged the king's passion for administrative detail by listening to meticulous instructions for painting the current skirmishes and sieges. Jules Hardouin Mansart, the king's architect, appears almost snuffed out under a periwig in Edelinck's elaborate engraving. Mansart designed almost all the buildings which today evoke the classic age of France—the

A. HYATT MAYOR

chapel at Versailles, the Galerie des glaces, the Grand Trianon, the place Vendôme, and the dome of the Invalides being a few of them. He launched innovations which were until yesterday the stock in trade of French architecture, such as double doors, the use of mirrors over mantelpieces, and wainscoting instead of tapestries. These things continue to flourish almost as vigorously as Louis XIV's system of state patronage of the arts, with its subsidized academies and schools, its salons, prizes, commissions, and scholarships in Rome.

The unanimity of taste imposed by the State's monopoly of the arts enabled artists to collaborate more closely than they have ever been able to since the *ancien régime* ended. But the authority of Louis XIV dominated the arts no more strictly than did the authority of classical antiquity and the Italian baroque. People agreed about taste because they all accepted certain kinds of work as standard. Imitation was then a catchword as current as originality is today. Since the ideal of imitation has dropped out of our present doctrine of art, it is enlightening to read Racine's intelligent defense: "Good imitation is constant invention. You must become your model, must better his inspirations and make them yours by reworking them. You must improve what you take, and not take what you cannot improve. . . . Imitation feeds and perfects your inborn gifts." Racine's statement illuminates not only his own relation to Euripides but also Molière's to Plautus and Terence, La Fontaine's to Aesop, and the relation of the great French engravers to the paintings they reproduced. By wisely modeling their technique on the work of the engravers whom Rubens specially trained to reproduce his paintings, they avoided the danger of letting details or mere dexterity distract from the total effect. Nanteuil said that "while an engraver works on one spot he must eye the whole." This striving for the spirit and not the letter makes the best of these seventeenth-century French reproductive engravings as free as the portraits which Nanteuil and others engraved from life. In the judgment of contemporaries the reproduction often surpassed the original.

The style which the French seventeenth century evolved for the engraved portrait pleased so generally that it lasted well into the next age. Although P. I. Drevet did not engrave Adrienne Lecouvreur's portrait until after her death, in 1730, the systematic interplay of the lines and the tablet inscribed with verses under the oval stone frame follow a formula then two generations old. The great actress's tear-glazed eyes, her tragic attitude with the urn of ashes, show how she looked in Corneille's *Mort de Pompée*, one of her triumphs. After fascinating Voltaire and his not easily fascinated age, she died at the height of her fame and beauty. Since the Church refused consecrated ground for burying the body of any stage player, even hers, two porters had to be got to lug the corpse into a cab and dump it into a hole in the rue de Bourgogne. The matter raised an outcry at the time and aggravated the anticlerical ill will, which burst forth during the Revolution.

The prints which have been presented to the Museum by the children of Elihu Root serve to strengthen the print collection in a wide variety of fields. The range of the gift may be suggested by mentioning a few of the non-French portraits. There is, for instance, Cornelis Visscher's brilliant engraving of Philip II, wearing a jaunty little Spanish top hat. His overripe lip and glum eye are as Titian always painted them. There is also a curious early English mezzotint, dated 1712, of Giovanni Cornaro in his doge's cap, by John Smith. With an unusual combination of techniques, the portrait proper is done in mezzotint and the rich ornamental border is engraved.

The gift also includes a photograph of Thomas Carlyle in profile by that vivid Victorian Julia Margaret Cameron, which now takes its place beside her portraits of Sir J. F. W. Herschel and Robert Browning in the Museum's small but fine collection of photographs. When, at the age of fifty, Mrs. Cameron was given a camera, she mastered the intricate and ticklish process of wet-plate photography and then dragooned her friends, among whom were Tennyson, Carlyle, and Darwin into posing precisely as she commanded. During her long friendship with

A. HYATT MAYOR

these famous men she was able to discover the pose and the lighting that disclosed their deepest characteristics. Her portraits are the most revealing records ever made of their faces. Her photograph of Carlyle shows him as he must have looked when alone and face to face with frustration, while Whistler's decorative painting presents a hero to his international public.

Carpentry and Candlelight in the Theater

The Metropolitan Museum of Art Bulletin n.s. 1, 6
FEBRUARY 1943: 198–203

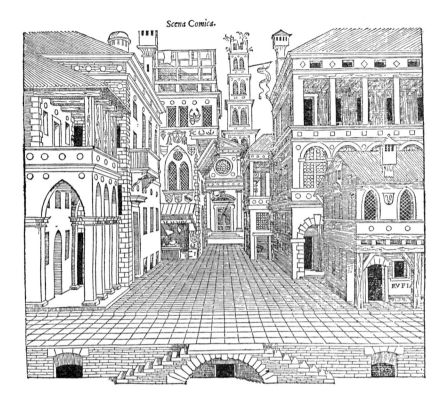

Scena Comica.

The set for comedies. Woodcut in Serlio, *Le Second Livre de perspective*.
Paris (Barbé), 1545.

Bequest of W. Gedney Beatty, 1941 (41.100.139).

\bigveeOLTAIRE REMARKED that Frenchmen wrote the good plays but Italians built the good theaters. The Italian leadership in theater design was no sudden accident but was like the Italian leadership in all the visual arts, the ripening of a millennial experience in the arts of form. Already in the first century B.C. Italy had produced the only surviving classical manual on theater design, where, mixed up with the current practice in building forts, houses, and temples, in constructing catapults and finding healthy water, in anything and everything that a Roman contractor-engineer might need, the author, Vitruvius, gives some involved instructions for planning theaters. Since his rules of thumb were received by renaissance and baroque architects like saws from Sinai, it is interesting to see what he says about theater scenery: "There are three sorts of scenes, tragic, comic, and satyric. Tragic scenes are ornamented with columns, pediments, statues, and other royal decorations. Comic scenes represent private buildings and galleries, with windows like those in ordinary houses. Satyric scenes are ornamented with trees, caves, hills, and other rural objects in imitation of nature." Since the extant Vitruvius manuscripts, which go back to about 900, are unillustrated, carrying out his instructions is a matter of guesswork, like trying to put together a prefabricated house without diagrams.

The first modern book on theater building was also written by an Italian, Sebastiano Serlio, though he published it in Paris in 1545 as a part of the first modern treatise on architecture to be printed with illustrations. The work appeared in English in 1611, when Shakespeare had just retired to Stratford and Ben Jonson, bitterly remarking that "painting and carpentry are the soul of masque," had realized that his poetry passed unheard by the audiences who applauded Inigo Jones's scenery and machines.

Serlio elaborated on Vitruvius's three sets. In the comic one, for instance, "the houses must be slight for Citizens, but specially there must not want a brawthell or bawdy house, and a great Inne, and a Church; for such things are of necessity to be therein." The "houses" in Serlio's woodcut are like those that used to be strung out along the side of a mediaeval town square to accommodate the various scenes of a miracle play. To bring these "houses" into a narrow proscenium stage, Serlio telescoped them and lined them up on either side of a perspective street. Indoor scenes were acted on balconies or porches, for Serlio's century felt that a room with no fourth wall was unnatural. Naturalness may be, like beauty, a variable of habit.

Serlio's set for satyric plays is also more mediaeval than classical, having many of the features of a crèche: "In our days these things were made in Winter, when there were but fewe greene Trees, Herbs and Flowres to be found; then you must make these things of Silke, and the more such things cost, the more they are esteemed. This have I seene in some Scenes made for the pleasure and delight of Francisco Maria, Duke of Urbin. Oh good Lord, what magnificence was there to be seene, for the great number of Trees and Fruits, with sundry Herbes and Flowres, all made of fine Silke of divers Collors. The water courses being adorned with Frogs, Snailes, Tortuses, Toads, Adders, Snakes and other beasts; Rootes of Corale, mother of Pearle and other shels layed and thrust through betweene the stones. I would speak of the costly apparel of some Shepheards made of cloth of gold, and of Silke, cunningly mingled with Imbrothery; of some Fishermen, having Nets and Angling-rods, all gilt; of some Countrey mayds and Nimphes carelessly apparelled without pride." Even such were the delights laid at the feet of Gloriana.

The oldest modern theater still existing is the Teatro Olimpico at Vicenza, planned by Palladio in imitation of a now vanished Roman theater near by. Palladio died a year after the work was started, leaving his pupil Scamozzi to carry out the permanent set of wood and plaster. Their tragic set has five streets

A. HYATT MAYOR

instead of Serlio's one, for they carried out Vitruvius's words with the greater rigor of a more archaeological generation. "In the middle are the royal doors," wrote Vitruvius, "those on the right and left are for the guests; and those at the ends are where the road turns off." Greek and Roman tragedies require the main entrance to lead indoors into a house or temple, but in the Olimpico each of the five arches leads into a perspective street like that in Serlio's woodcut. Had the builders filled in Vitruvius's gaps without looking for indications in the tragedies themselves? Or were they so enamored of perspective that they applied it even where they knew it did not fit the action? It probably mattered little anyway, for the Olimpico was used mostly for declaiming the static closet dramas of Seneca and his renaissance imitators. This attempt to reconstruct an antique theater and to revive antique tragedy in it led to two developments—the modern theater and the opera—which would have surprised the archaeological literati of the sixteenth century. An excursion into the past often opens up the future.

In 1619, just when Monteverdi was bringing opera to life, Giovanni Battista Aleotti created the oldest theater which still looks workable. This first big modern theater is the Teatro Farnese, which is built of wood in a riding school in Parma and is said to hold four thousand. The roomy stage once had huge pulleys and windlasses to shift canvas scenery, since a permanent set in sculpture, like the Olimpico's, was already a historical oddity. The proscenium arch is rich with carving and columns that project the richness of the scenery out into the house, where lights burned almost as brightly as on the stage. Baroque taste demanded unity in a room and wished the fairyland of the stage to expand right out around and above and behind the audience.

The audience sat on old Roman stadium steps like those in the semicircle at the Olimpico, but the Parma bleachers were bent into a deep U. Above the steps were two tiers of ornamental arches that look like the Colosseum turned outside in. Parma already had the essentials of the conventional opera house, which the Italians perfected about 1680 when they closed in

the U to form a truncated oval and developed the arcades into tiers of shallow boxes. Good for hearing and seeing, the oval of boxes seats many people cheaply and looks full and festive even if really half empty. In 1778 this plan produced its masterpiece in La Scala in Milan, which seats five hundred more than our Metropolitan Opera and is still Europe's largest opera house. Its six tiers of shallow boxes and its small foyers suit the Italians, who visit each other's boxes during intermissions instead of milling in the foyers like the French and the Americans.

The Metropolitan Opera House follows the Italian plan even to the inadequate foyers. The placing of our exits, stage entrance, box office, and so forth is in the tradition which started in 1737 with the San Carlo in Naples, the first modern theater in which function shaped the whole building inside and out. The French varied the Italian plan hardly more than by enlarging the foyers and making the auditorium more decorative. Since the French considered the house part of the spectacle, and went to the theater to be seen as well as to see, the proscenium is sometimes made of boxes for a changing decoration of ornamental ladies. A wise French architect wrote in the 1880's: "The auditorium must make a flattering background for people. Red is the safest color, since it warms the eye and glows against dresses, cheeks and jewels. Never use green or yellow, for no lady will show herself twice in a theater that makes her look sallow."

The Italian auditorium prevailed far and wide until Wagner designed the Bayreuth Opera in 1871 in the shape of a partly opened fan. The usual New York auditorium is in such a fan shape, only wider and shallower and equipped with the deep balconies that are necessary to make this plan seat enough people to pay. Such deep balconies were impossible before electric lighting, since their recesses, if lighted by candles or gas, would have been suffocating.

Lighting equipment has dominated the development of scenery. Oddly enough the classic daylit theaters—the Greek, the Chinese, and the Elizabethan—dressed their actors richly

A. HYATT MAYOR

but were content with the simplest suggestions of scene. Was this because daylight cannot be tempered or colored and darkness cannot be turned on for changes? Was it because an audience does not miss scenery where the shifting and lengthening of shadows paces the action of a drama that is geared to the clockwork of the sun? Imagine Shakespeare's playhouse when Cleopatra was dallying with death as the wanness of a London winter afternoon drained away, leaving the dark for Caesar's torches to rush into and disclose her dead. Think how the ordnance must have thundered when Hamlet was borne off the stage as the first stars began to twinkle. The bareness of the Elizabethan carpentry was in exquisite taste, for it offered no distraction from the splendor of the language or the decline of the afternoon.

But in an indoor theater the paltriness of man's substitutes for sunlight cries for the distraction of scenery. The Italian renaissance theater used lights to decorate as well as to illumine the stage. Serlio outlined his "houses" with sparklers made by lighting candles behind lens-shaped bottles filled with colored waters, like those in an old-fashioned druggist's window, red wine suggesting the "rubbies," white wine the topazes, and "common water strayned" the diamonds. "The bottels," he cautioned, "must be set fast lest they fall with leaping and dancing of the Moriscoes." Since strings of colored lights were practical for fixed sets but were too complicated to install in changing scenery, the flats and backdrops that came into use at the time of the Farnese Theater had to be lighted indirectly. Indirect lighting brought a fresh set of troubles, for it was almost impossible to keep the actors from casting shadows on the painted vistas, and the required banks of candles smoked so hotly that windows had to be opened above the stage lest the latter half of the spectacle vanish in soot. At one time Charles I stopped holding masques in the banqueting hall at Whitehall lest "the smoke of many lights" blacken Rubens's new ceiling. Nobody seemed to fear a conflagration, for Serlio cavalierly says that if there is "something or other which should seeme to

burne, you must wet it thoroughly with excellent good Aquavite, and setting it on fire with a candle it will burn all over." The glimmering dimness of no matter how many hundred candles swallowed up most colors, but what of that? The baroque theater enchanted with linear perspective, so that "a man in a small space might see great Palaces, large Temples, neere and farre off, long streets crosst with other wayes, Tryumphant Arches, Columnes, Piramides and Obeliscens." Around 1700 the Bibiena family (Europe's stage magicians for over a century) perfected diagonal perspective, leading the eye out to right and left toward endlessness. The delight of such settings can be guessed from the old Bakst backdrop that was used until a year or so ago for the ballet "Aurora's Wedding." Perspective scenery could have flourished only in the great age of autocrats, since the illusion of depth is more or less askew for everybody except the prince enthroned in the one box which is both at the level of the horizon line and square on axis. In spite of this, Italian designers continued to enchant every audience in Europe with the magic of immensity until 1784, when the Argand lamp broke the spell with the first notable improvement in illumination for a thousand years or so. As ever brighter lights enabled audiences to see more colors in stage scenery and to distinguish a painted cloth from real distances, designers were forced to make their sets look less like perspective drawings and more like easel paintings. Stage design caught up with romantic painting, kept pace with the progress of naturalism, and finally became photographic in its literalness. Design and geometry did not reappear on the stage until after 1900, when strong electric light bulbs allowed spotlighting to become a basic part of the effect, or made it possible to design entirely with light. The baroque illusion of immensity returned with Gordon Craig.

But just because the baroque theater got along with candles and handpower one must not imagine that its marvels were limited. As early as 1637 Niccolo Sabbattini's *Pratica di fabbricar scene e machine ne' teatri*, the earliest book on stage machinery and transformations, tells how to show a town collapsing into

A. HYATT MAYOR

ruin, make hell appear and mountains rise, lower clouds with gods in them, raise phantoms and disperse them, change a man into a rock and back again, conjure up the sea, and make it swell, storm, and darken while dolphins guide ships through the whitecaps. During the more difficult of these transformations Sabbattini suggests distracting the audience's attention by having a couple of strong-lunged men bellow "Fire!" Stage machines made more contemporary reputations than painted perspectives.

The baroque statesman used the stage designer just as every autocrat has done up to Mussolini and Hitler. When a prince took over the government of a town he made this clear to everybody by spanning the streets with scenery arches and parading under them in a pageant. When a prince died a stage designer —a Bibiena or a Galliari—concocted a seventy-foot catafalque of columns and hoisted the draped casket halfway up, to be shown among urns belching heavy flames and skeletons flashing scythes. For Easter and the canonization of the new saints of the Counter Reformation, the Jesuit father Andrea Pozzo extinguished the high altar beneath a tower that soared up into clouds which expanded like incense and pillowed the newest martyrs as they swooned to the shudderings of the organ. The baroque has rightly been called *Jesuitenkunst*, for Saint Ignatius's *Spiritual Exercises* are a classic manual of methods for attacking the spirit through all the senses. When Church and State proclaimed their high doings with spectacular ceremonial, life offered more contrasts than now, and one day differed more from another.

With this inexhaustible theatricality, why did not the Italians produce plays that found as wide a currency as their theaters, their scenery, and their operas? One reason must be that the Italian stage became most active after the French had invaded Italy and sacked Rome and the Spaniards had occupied Naples. In the discouragement of becoming vassals it is no wonder that the Italians turned back to dreams of old Rome and that their antiquarian academies saw no refuge except in archae-

ological revivals of Seneca and Vitruvius. Opera throve on the Italian desire to fuse various arts to one end, but tragedy was snowed under court spectacle. Italian tragic writers found no inspiring theme, as Corneille and Racine did in monarchical unity, Lope and Calderón in the fanaticism of honor, and the Elizabethans in love of England. Italian comedy fared hardly better. Since the actors of the commedia dell' arte owed their professional or guild (*dell' arte*) status to their ability to improvise dialogue for any given scenario, they refused to surrender their authors' privileges by acting to a written text. The commedia might have left hardly a memory of its brilliance had it not had its greatest success at the French court, where a century of residence produced a tradition that nurtured Molière. Voltaire was perhaps not quite right in saying that Italy had produced the theaters and France the plays, since Molière's early comedies belong as much to Italy as any of Goldoni's. This was art's revenge upon the conqueror.

The Photographic Eye

The Metropolitan Museum of Art Bulletin n.s. 5, 1

SUMMER, 1946: 15–26

Photographic—Accurately portraying life or nature; minutely accurate; mechanically imitative.—*Oxford Dictionary*

T HOUGH MAGNIFIERS, drawing machines, and cameras have been used in making works of art for a long time, their connection with technique and style has received only passing mention. Yet devices that affect the way we see are bound to affect style in art, since style both reflects and conditions ways of seeing.

Everybody's seeing is constantly changing. The hat that startled at Easter looks normal in May and will be dowdy by August. In the first Cézannes that I remember facing, at the age of twenty-three, I could not identify the objects represented. Like the Australian bushman who was shown a photograph of himself, I asked, "What is it?" Yet it took only a few months for valley views and stone villages to reveal themselves in Cézanne's coloring and rhythms.

A history of seeing can be demonstrated by the widely differing kinds of pictures that were considered lifelike in their day. Near Eastern painting, which charms us like a bright patchwork, was to its makers and patrons a window into a real world. In the tenth century a poet described an embroidered tent at Antioch by saying, "Whene'er the tent-side billows with the wind,/The horses ramp and lions outwit their prey."[1] According to Vasari the laurel in the background of the Museum's Madonna by Girolamo dai Libri was so "truly a living tree, graceful and most natural," that birds used to fly into the church where it hung to perch on its branches. This charming but rather prim tree would probably not fool today's sparrows any more than the grapes that Zeuxis painted.

1. Sir Thomas W. Arnold, *Painting in Islam* (Oxford, 1928), p. 21.

The first inventions that modified man's seeing, and thereby affected art, were probably magnifiers, which seem to have been used very early in the mass production of engraved seals. Seals were indispensable to law and commerce in antiquity, when a man impressed his seal to padlock his tied-up deeds and his wine jars or to sign letters and documents and perhaps lent it as his power of attorney. Since every man of property kept his seal on his person even in his bath and his bed, he had to have it as portable as an amulet, preferred it to be pretty, and was wise if he got it hard enough to wear for a lifetime without noticeably debasing the impression. For these reasons most surviving ancient seals are small and durable, proofed against forgery by their individuality.

Three or four thousand years ago seal-makers in the Near East were already grinding designs on stone and shell with little disks and drills substantially like those that whirl today under more convenient power. But the scale of early seal-engraving gradually ceased to be comfortable to the naked eye, as the Minoans and even more the classical Greeks succeeded in engraving figures as tiny as a baby's thumb-nail and yet so finished that when photographs of them are enlarged to wall-size the rhythms seem still more alive and the details more exactly proportioned. This perfection in minuteness recurs too often to be attributed altogether to precocious geniuses or to those unusual eyes that see better close up as they grow older. Though the eighteenth century carried its adulation of classical antiquity to the point of postulating a vanished race of men with superior eyes, Greek and Roman eyes must have ached like any of ours for Pliny the Elder to report that gem-engravers and painters strengthened their sight by eating bread sprinkled with rue and that engravers refreshed their eyes by gazing into the cool green of emeralds.

That antiquity should have left us no account of the gem-engraver's use of magnifiers is not surprising, since most ancient critics confined themselves to appreciating finished works of art and passed over the workshop's sweaty, sloppy, dusty inevitabilities. In our machine age, however, these very technical pro-

A. HYATT MAYOR

cesses preoccupy the many archaeologists who have debated this question of lenses in antiquity. Their discussion is excellently summarized in Gisela M. A. Richter's *Catalogue of Engraved Gems of the Classical Style*, which is the source of most of the facts stated here. The upshot seems to be that the ancients knew and used the phenomenon of magnification, but there is little certainty what kind or how early.

One thing is certain: glass, now the commonest material for magnification, was so used very late. In the first century after Christ, Seneca said that small and indistinct writing looked big and clear through a glass globe full of water, and graves in various parts of the Roman Empire have yielded solid glass lenses shaped either like half oranges or like balls that have been squeezed in a tube. Both of these magnifiers could only have been made after the first century B.C., when the art of glass-blowing was invented and really transparent glass was produced in addition to the earlier colored, opaque glass.

The Greek gem-engraver's use of lenses may perhaps be determined from the form of the gems themselves. About 1600 B.C. the Minoans invented seals of a double convex shape—the so-called lentoid gems that look like pills an inch or less across and half as thick. Before engraving the design on one side, both sides were probably polished, or such at least was the procedure over a thousand years later in making a Hellenistic gem that has survived half-finished. When a Minoan gem-cutter polished a lentoid blank in rock crystal (a material he often used), he had in his hands as good a short-focus lens as man was to possess until Galileo's time. A rock-crystal lens is probably what is referred to in Aristophanes's *Clouds* (423 B.C.) when a character says that with one of the druggists' transparent stones for making fire he will focus the sunlight to melt away the letters on a wax tablet as fast as the law clerk inscribes them. Pliny's *Natural History* (dedicated in 77 A.D.) recommends rock crystal for focusing sunlight to cauterize wounds.

The Egyptians had at least two devices for magnifying that could have served an artisan. Nora E. Scott has pointed out that

from an early period their statues and coffins were given eyes with rock-crystal corneas. Several of these would make strong short-focus plano-convex lenses if the flat back were polished like the convex front, and even as they are they magnify quite well if the unpolished back is slicked by wetting. Though the Egyptians may not have had the dime-novel notion of stealing their statues' eyes to improve their own, they used the principle of magnification in their metal hand mirrors, which, even in the early dynasties, they made flat, convex, or concave. Egyptian jewelers may well have found concave mirrors as convenient for exquisitely exact work as dentists do today.

In short, the Egyptians, the Minoans, and the Greeks might quite possibly have used a variety of magnifiers for their microscopic craftsmanship too commonly to attract the notice of ancient writers.

Man held short-focus magnifying glasses for ten or twenty centuries before it occurred to him to free both hands by balancing a pair of long-focus lenses on his nose. The emerald through which Nero watched slums burn and gladiators bleed was probably not mounted like eyeglasses, which would seem to have been invented in the late twelve hundreds in Italy and were first prescribed instead of herbs for treating eye trouble around 1300. What may be the earliest picture of a man wearing them occurs in a fresco of 1352 in Treviso, less than twenty miles from the great glassworks at Venice.

If short-focus lenses seem to have made possible a more minute accuracy in works of art, what effect might eyeglasses have had? Testimony from an eyewitness—in the most literal sense—comes from the oddest of sources, a letter in the Library of Congress, written to Jefferson by Charles Willson Peale when he was seventy-six:

> Since I have resumed my Pencil I make use of a pr. of thos Spectacles of 3 feet focus, which enables me to see my Sitter and also my picture nearly as well as I could at a much earlier time of life, therefore I am enabled to give a higher finish to my work than I had done of late. . . . Soon after I had resumed my prac-

A. HYATT MAYOR

tice of painting portraits, I found that the Heads which I painted
with Spectacles were smaller than life, which I have ever con-
sidered a bad taste, unless they were very considerably small.
Therefore I afterwards found it best to paint the first sitting
without Spectacles, by which I could make the general effect in
proportion and even a strong likeness, but my painting was very
rough, afterwards I blended the various tints together and thus
softened the work to please the common Eye.

The fact that details blur and colors blend into opalescence in
the circles of confusion of aging eyes may explain why the old
and all but blind Degas drew figures of dreamlike amplitude.

It has been pointed out that the adoption of eyeglasses, by
enabling old men to keep on reading and writing, contributed
to the huge increase in scholarship that marked the late Middle
Ages and the Renaissance. Could it also have contributed to
that new realism in painting associated with the Van Eycks? If
glasses made Peale paint smaller than life and with a higher
finish, may they not have helped the Van Eycks to achieve unity
and grandeur in pictures sometimes no bigger than this page?
A lens held in the hand would not do for them, as it could quite
comfortably have done for their miniaturist predecessors, nig-
gling over diaper patterns and jewel-like but scattered details.
Unlike earlier miniaturists, the Van Eycks considered the whole
of a picture every time their brush touched it; for their still un-
rivaled achievement was to paint in detail while subordinating
each stroke to a unity of shape and color observed in nature. If
their eyes blurred—as most would at such a rate of use—it is
hard to see how they could have kept on working without re-
sorting to eyeglasses.

During the last years of Jan van Eyck's pioneer investigation
into what happens when colored shapes slope into shadow, an
Italian was working out the mathematics of perspective con-
struction. With the Van Eycks to show how to paint color in
light and shade and Alberti to show how to draw objects in
depth, a painter was for the first time equipped to represent a
room as the camera sees it. But perspective is not easy for every

man. It demands a combination of mathematical interest and sensuous awareness that was rarer north of the Alps than in Italy.

After Dürer had struggled with the problem for most of his life, he made four woodcuts of four mechanical devices for drawing in perspective without bothering about the mathematics. These drawing machines of about 1525 show the spread of the revolutionary renaissance ambition to represent a depth of air furnished with objects all seen from a single point of view. The most practical of Dürer's drawing machines consisted of a peephole fixed on top of a stick a foot or so in front of an upright pane of glass. The artist kept his eye steady by gazing through the peephole while he outlined his subject on the glass in paint or fatty crayon or soap. If the artist found it hard to copy off the proportions and perspective thus obtained, he could transfer his outlines mechanically by pressing a sheet of paper against the glass to print off the greasy lines he had drawn there. Joseph Meder says that such oily outlines are to be seen on some of Holbein's portrait drawings, which are indeed the most crisp, flat, monocular charts of faces ever drawn. Some mechanical aid must have helped Holbein in his specialty of catching likenesses of preoccupied courtiers, who undoubtedly sat as Dürer's woodcut (illustrated opposite) shows a prince, tapping the arm of a chair for a moment grudged between appointments. The suspicion is confirmed by the fact that quite recently Emil Orlik was obtaining Holbein's flat accuracy in portraits made with Dürer's drawing machine.

Dürer's drawing machine was reinvented by John Constable, who "when he was studying the art of painting in his native place, unaided by others," bolted a pane of glass to his easel and kept his eye steady in front of it by tying four strings to the four corners and gathering the loose ends between his teeth. "On this glass, thus held and secured from shifting, he traced with colour the outline of the view. From this sketch he made his painting. Afterwards studying in the schools of art, he followed

A. HYATT MAYOR

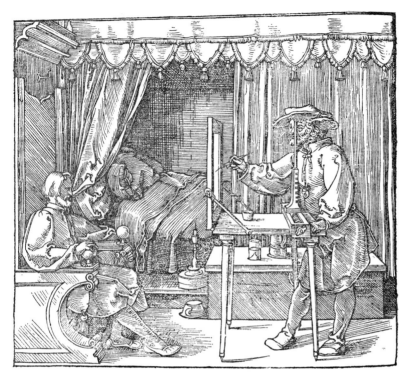

Albrecht Dürer. A drawing machine. Woodcut in *Underweysung der Messung* (*A Course in Measurement*). Nuremberg, 1525.

Gift of Felix M. Warburg, 1918 (18.58.3).

the rules of those schools, and fell into the popular errors as he admitted and regretted."[2]

Less than fifty years after Dürer had made the earliest pictures of drawing machines, a way was found to focus an image through a lens directly onto a piece of paper strongly and sharply enough to trace with a pen or pencil. Aristotle had long before remarked that the image of an outdoor scene could be projected through a little hole into a dark chamber. The an-

2. Arthur Parsey, *The Science of Vision* (London, 1840), p. 134.

cients cannot have failed to notice that an even stronger projection, though too small for easy experimentation, was cast by their short-focus lenses.

After the basic machinery of the photographic camera had lain unassembled for centuries, it was finally put together by a Venetian diplomat and writer on architecture, Daniele Barbaro, who in 1568 printed the first description of a camera obscura with lens. The clarity and poetic vividness of his account make it worth quoting:

> If you wish to study the outlines, colors, and shadows of things as nature spaces them in distance, make a hole in a window shutter and set in it a thick lens from an old man's eyeglasses (not a thin lens made for a young man). Now close all the shutters and doors until no light enters the chamber except through the lens, and opposite it hold a sheet of paper, which you move forward and backward until the scene appears in the sharpest detail. There on the paper you will see the whole view as it really is, with its distances, its colors and shadows and motion, the clouds, the water twinkling, the birds flying. If you partly cover the lens to leave only a small aperture, the image grows sharper. By holding the paper steady you can trace the whole perspective outline with a pen, shade it, and delicately color it from nature.[3]

Note that the first description of a usable camera obscura puts it immediately at the service of the draftsman of views. As ever in Italy, science and art went hand in hand.

The number of subsequent accounts of the camera obscura shows that it must have become a usual tool for accuracy when drawing views, portraits, and scientific illustrations. Without such a short cut to the complications of architectural perspective, the manufacture of inexpensive copperplate views, which grew into a widespread industry only to be ruined by Daguerre, could hardly have made money. During the eighteenth century alone, Augsburg and Paris turned out thousands of so-called *vues d'optique*—rough etchings of places all over the world that bear several lines of description at the bottom and a line of mir-

3. Daniele Barbaro, *Pratica della perspettiva* (Venice, 1568-1569), p. 192.

A. HYATT MAYOR

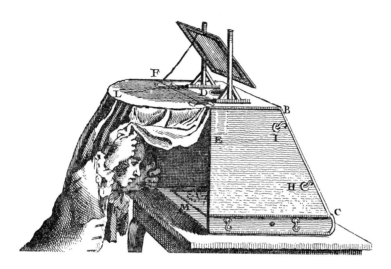

A portable camera obscura. Engraving in Jombert, *Méthode pour apprende le dessein.* Paris, 1755.

Harris Brisbane Dick Fund, 1932 (32.55.4).

ror printing at the top. These forerunners of the stereoscope and the travel movie were manufactured in a fairly standard size so as to fit the viewers, which consisted of an upright lens as big as a shaving mirror through which the print was reflected swimmingly in a tilted looking-glass. These viewers, which must have been in every home, to judge by the quantities of prints made for them, were no more complicated than the portable model of the camera obscura illustrated above.

Allyn Cox has suggested that the camera obscura might have been used by one of the most exquisitely deliberate painters, Vermeer himself. It may be objected that while the camera obscura as described by Barbaro casts a reversed image, Vermeer's paintings show everything the right way around. For instance, the painter in a studio scene holds his brush in his right hand; and the four maps that appear in five of Vermeer's paintings are all correctly rendered. But he could perfectly well have righted a camera image by using two convex lenses, as Kepler recom-

mended for drawing[4] about twenty years before Vermeer was born, or by placing a forty-five-degree mirror above a horizontal single lens as has been done in the camera obscura illustrated. It might also be objected that Vermeer could not have achieved his impeccable assemblage of shapes—a finality of repose established like the entablature of the Parthenon—by arranging actual objects before a lens. Yet since no other painter, with all the liberty in the world, has ever surpassed that last gravity of balance, why should Vermeer not have painted from a camera image just as well as direct from nature?

The assumption that he painted from a camera obscura would explain a number of peculiarities in his art. In the image cast by a lens Goethe noticed that "everything is covered with a faint bloom, a kind of smokiness that reminds many painters of lard, and that fastens like a vice on the painter who works from the camera obscura." Such an effect is one of the fascinations of Vermeer, who used more colors than almost any other great painter, yet blended every combination as perfectly as the ground glass of a camera. Also the highlights on objects in the immediate foreground—the carved lion-head of a chair or the bright threads of a tapestry—break up into dots like globules of halation swimming on ground glass. By throwing near-by objects out of focus, as it were, Vermeer suggested depth with a device more subtle than the standard practice of making them markedly lighter or darker than what is behind.

Vermeer was blamed for drawing near objects too big and far objects too small. Most painters before the age of photography were in the habit of evening out sizes as modified by distance in order to approximate the correction that we unconsciously make by the convergence of our eyes, a compensation which may be what Constable meant by the popular errors of the schools. Though the dime that I hold at arm's length covers the moon, I know it is really smaller because the crossing of my eyes tells me it is so vastly closer. Yet if I look with one eye or take a pho-

4. Johann Kepler, *Dioptrice* (Augsburg, 1611), propositio XXCIIX (88).

A. HYATT MAYOR

tograph or make a correct perspective outline of the moon and the dime I have no difference of convergence to tell me which is bigger. Now if Vermeer were painting from an image seen in the camera obscura, his eyes would not converge more for a near object than for a far one and he would tend to paint near objects bigger and far objects smaller than if he were painting direct from nature.

A memory of his practice might be preserved in a chance reference made by G. J. s'Gravesande, who was born thirteen years after Vermeer's death: "Several Dutch painters are said to have studied and imitated, in their paintings, the effect of the camera obscura and its manner of showing nature, which has led some people to think that the camera could help them to understand light or chiaroscuro. The effect of the camera is striking, but false."[5] May it not be that the "falsity" of Vermeer's perspective helped to keep him in obscurity until after the 1860's, when the ubiquitousness of photography had conditioned men's eyes to another way of looking at the world? At any rate it is certain that to a modern eye, accustomed to seeing the world through photographs, Vermeer's near objects no longer look exaggeratedly big.

The eye of any age is so subtly yet inexorably a part of the mind of that age that one is tempted to wonder if photography could have been invented at any time before the 1830's in spite of the fact that the elements had been on hand for centuries. Certainly the photograph would have seemed a distraction of vicious curiosity to the mediaeval scrutiny of everything for possible symbolism and moral value. And the mannerist world, though it showed its liking for architectural perspective by assembling the camera obscura with lens, would have rejected most photographs of the human figure for being so far from its canon of proportion. But in the 1830's Balzac wanted to examine and record his surroundings down to the last item, and Ingres won applause with his painting of clean-edged light and shade.

5. Quoted in C. A. Jombert, *Méthode pour apprendre le dessein* (Paris, 1755), p. 139.

The desire for exact and unlimited detail and smooth chiaroscuro was probably the incentive that started Fox Talbot on the search that discovered the negative-positive process of photography. In 1833, when Talbot was sketching a landscape with a camera lucida, he found that his "faithless pencil had only left traces on the paper melancholy to behold." Now since the camera lucida is a drawing machine that makes the most complicated perspective as simple as tracing, Talbot, who could not have been dissatisfied with the exactness of his outlines, probably wanted more accurate values of light and shade. Daguerre, the other inventor of photography, was then making himself famous in Paris by the mastery of light and shade that he showed in painting stage scenery on thin cloth to be transformed by lights from behind.

The spread of photography made "photographic" art cease to pay. In 1842, only three years after the announcement of the discovery, over twelve hundred daguerreotype views in a Paris gallery were reporting the appearance of foreign places with more accurate detail than the best-trained hand could draw. In the course of a couple of generations photography not only took away the bread and butter from the main bulk of draftsmen— the news reporters and specimen gatherers for mankind—who had for over three centuries informed the learned and the illiterate about the look of the world, but it also squeezed out the engravers who copied those drawings on copper and wood for printing. Why should a man spend years learning to do what a child can accomplish better by clicking a box camera?

So long as illustrations were produced by a team of draftsmen and engravers, consistency could be achieved only when both groups of artists had been taught to draw alike. As factual draftsmanship ceased to provide a livelihood for most artists, the art schools ceased to train so intensively by literal copying. While this meant that some art students never learned to draw at all, it also meant that all were not pressed so tightly as formerly into a uniform mold. Without such a loosening up of the curriculum in art schools modern art could not so readily have

78 A. HYATT MAYOR

developed its unprecedented diversity of styles. Thus it is that photography, by taking on the drudgery of pictorial reporting, gave expressiveness a freer hand in art than it had had since the Middle Ages. The very invention that was born of a desire for the most detailed realism not only discredited that realism by too quick and easy a satisfaction, but in time stimulated art with undreamed-of revelations of form and action.

Photography has fascinated and influenced some of the greatest artists since 1839. Degas and Thomas Eakins, to name only two, both gave their serious thought to taking photographs as works of art. By getting someone else to release the shutter, both men often photographed themselves, not from vanity, but from convenience, since every artist can count on himself as his most available sitter. When Degas was fifty he wrote a curious letter in which he criticized, in greater detail than he used in writing about his paintings, a photograph where he had recently grouped several ladies in bustles around him in a parody of Ingres's *Apotheosis of Homer*. It is odd that while his photographs, like Eakins's, show the same characteristics of vision as his paintings, they do not show the "photographic" innovations that he painted and drew. For Degas would seem to have used certain peculiarities of photography for imaginative effect in his painting, such as his trick, in which he far outdoes Vermeer, of making near objects loom immense. When he blows up the clean, abstract shape of a near-by double-bass head or a milliner's hat until it balances a mass of figures in the middle ground he composes in depth as he does in surface extension, by counterpoising spots.

Degas's eye ferreted and foraged among too wide a diversity of pictures for us to discover the germs of some of his inventions. Though it is tempting, for instance, to think that the figures that have walked half off some of his canvases might have been suggested to him by photographs of street scenes or careless family snapshots, he did most of his painting before the photograph became cheap and easy enough for casual snapping. He is more likely to have got his idea for his sliced figures from the

Japanese pillar prints that advertised reigning geishas in posters shaped like upright strips so they could be pasted on wooden posts in teahouses. Since any figure tall enough to catch the eye from a distance was wider than the slender wooden pillars, the Japanese, like any true artists, made a virtue of necessity by designing figures that looked right only when sliced off at the sides.

There is, however, another matter in which Degas seems to have had a more easily demonstrable connection with photography. His drawing of horses in action was the first complete break with tradition as represented either by the English eighteenth-century rockinghorse gallop or by the monumental baroque horse careering above a stump. How is it that Degas succeeded in accurately catching that elusive horse action—the thoroughbred's highstrung, jumpy instability—when the specialists like Leonardo, Stubbs, Marshall, and Géricault had not come anywhere near as close? Degas did not benefit by Muybridge's pioneer photographic analysis of horse action, for he was already painting his characteristic horse action in the late 60's and early 70's, before Muybridge had begun to photograph horses in 1872 and long before his results first reached France late in 1878.

A possible answer is suggested in an article pointed out to me by Mrs. Beaumont Newhall, "The Human Wheel," which Oliver Wendell Holmes wrote for the *Atlantic Monthly* in 1863, when articulated wooden legs were being devised for the wounded of the Civil War. Holmes said of the mechanism of walking:

> We thought we could add something to what is known about it from a new source, accessible only within the last few years, namely the *instantaneous photograph*. We have selected [for reproduction] a number of instantaneous steroescope views of the streets and public places of Paris and New York, each of them showing numerous walking figures, among which some may be found in every stage of the complex act. No artist would have dared to draw a walking figure in attitudes like some of these.

The wet plate then available was too slow for what we today

A. HYATT MAYOR

would call instantaneous photography, but old stereoscope views nevertheless show cab horses stopped suddenly enough to give an extraordinarily quick eye, like Degas's, an inkling of what to look for on the race track. This may well be the answer, for the attitudes of Degas's horses, while truer than those of any painter before him, are not the cataleptic, nightmare suspensions that were first revealed to the world through Muybridge's photographs of the gallop. Degas would certainly not have thought it beneath him to study horse action in stereoscope views since he painted at least one portrait entirely from a photograph. Indeed, with his habitual mixing of media—pastel on monotype, oil on gouache—it is a wonder that he never painted right over an actual photograph. Or did he?

Though Degas did not draw horses from Muybridge's serial photographs of action, perhaps because he was too contrary to take up an idea after it had burst on every artist's mind, in later life he subtly adapted suggestions from Muybridge. Muybridge photographed animals and human beings as they ran, flew, jumped, pitched balls, or mopped floors in front of a battery of cameras whose shutters clicked in swift succession. The resulting series of photographs shows an action arrested in successive stages of development. After 1878 Degas also began to deploy figures in successive stages of an action. Ballet girls lent themselves admirably to this evolution of a gesture because their tutus, alike in all but color, and their elaborately standardized attitudes make them like almost the same person doing almost the same thing at almost the same time.

About 1884 Thomas Eakins, one of Muybridge's co-workers whose collaboration has only lately received attention, took time off from his painting to make photographs of action by a slightly different method. He used one camera to make a rapid series of exposures on one plate (illustrated page 82). Where Muybridge separated the stages of action like playing cards dealt out for solitaire, Eakins stacked one on top of the other to satisfy his mathematical passion for relations. It was a step towards that series of pictures rapidly replacing each other on one spot

The Photographic Eye 81

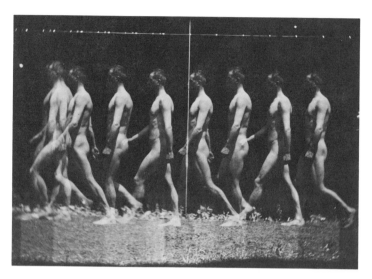

Thomas Eakins. *Jesse Godley*. Multiple exposure on a single negative, made with the Marey apparatus, 1884.

Gift of Charles Bregler, 1944 (44.75.10).

which is the movie. Eakins never bothered to publish his photographs, perhaps because in 1882 and 1883 his correspondent, Étienne Jules Marey, had already published the same sort of photographs in *La Nature*. This publication of what amounts to pictures of Bergson's idea of time rolling up on itself did not attract special attention at the moment, but when Marcel Duchamp translated the same idea into oil painting in 1912, his *Nude Descending the Stairs*, like the first night of Hugo's *Hernani*, called up one of those storms of protest that mark the outburst of an intellectual revolt. An idea that has passed without comment in photography strikes indignation thirty years later in painting, for in art as in morals we judge separate categories of things by separate standards. Once I picked up a little urn of pink and gray marble, but dropped it instantly when it squashed. It was not marble, but rubber, and rubberiness, while not in itself distasteful, becomes repulsive where solidity has

A. HYATT MAYOR

been expected. We dislike seeing a man paint what we accept from a camera.

Instantaneous photography, that microscope of time, which began by opening our eyes to things at home and in the street, nowadays reports the unseen—even the unseeable. And so it is also with the microscope of space that first confirmed what a sharp eye might guess and now reveals what few eyes can believe. Greek lenses, with their low magnification, and even the early compound microscope that was developed in Holland about 1600 showed things that do not look so very different from things big enough to feel in the hand. Yet the Dutch advance in exploring the world of littleness was startling enough to make it no accident that Leeuwenhoek should have been discovering tiny forms of life with his microscope in Delft during the very years when Gerard Douw in Leiden was painting with strokes so minute that he had to make his own brushes and always sat still at his easel until all dust had settled before he put on his eyeglasses and opened his paintbox. While the first microscopes seemed to lead toward the most prosy stock-taking of facts, the larger magnifications which culminate in the electron microscope peer into a world of angles and ovals that hardly resemble any natural shapes that we can see unaided. Not only has the world revealed by the senses become a shell encasing God knows what, but the physicist has had to abandon his old ideas of matter and to adventure among electrons and protons.

> The physicist used to borrow the raw material of his world from the familiar world, but he does so no longer. The external world of physics has thus become a world of shadows. In removing our illusion we have removed the substance, for indeed we have seen that substance is one of the greatest of our illusions. The frank realisation that physical science is concerned with a world of shadows is an assertion of freedom for autonomous development.

These words were spoken by A. S. Eddington in 1927, in the ripe heyday of abstract art; they might have been written, changing "science" to "art," by Klee or Picasso or Kandinsky. Logic

and sensibility are aboard the same train even though they ride in separate cars and disconcert each other when they meet. While they thought they were traveling toward something "minutely accurate, mechanically imitative," the train has whirled away through the night somewhere north of illusion and west of dream.

Renaissance Pamphleteers: Savonarola and Luther

The Metropolitan Museum of Art Bulletin n.s. 6, 2

OCTOBER 1947: 66–72

"Death Showing a Man Heaven and Hell." Woodcut in Savonarola, *Predica del arte del bene morire*. Florence (Tubini), about 1500.

Harris Brisbane Dick Fund, 1925 (25.30.95).

TRACTS WRITTEN TO INFLUENCE public opinion could have been published as soon as reading became a common accomplishment. They were certainly circulating in the time of Saint Paul, who is still the most widely read of pamphleteers. Since then the economics of pamphlet publishing have changed more slowly than is generally realized. Pamphlets have always had to be produced about as cheaply as today's magazines in order to spread a message widely. Under Augustus scribes already could turn out short works in editions of a thousand in a fortnight or so, which seems to compare not unfavorably with the speed of printing with movable type a millennium and a half later. In 1505 at Florence printers of Savonarola's sermons contracted to strike off a minimum of one sheet printed on both sides (*almanco uno foglo intero*, or eight octavo leaves) in a thousand copies each working day. The slowness of the payments seems to show, however, that the printers could not maintain this speed. For small editions of short works, indeed, scribes had the edge over printers, since they could go into production with less preparation and less overhead. Where scribes were strongly organized and had built up a big stockpile of manuscripts, as in mediaeval Paris, their competition actually retarded the introduction of printing.

Since scribes were able to supply a sizeable reading public, the invention of printing cannot be a major reason why Savonarola's and Luther's utterances made such a wide and lasting impression compared with the homilies of other vernacular preachers who swarmed in the century or so before them. These earlier reformers may have moved men only briefly and locally because their sermons reached readers without effective illustrations. While words can be written almost as accurately as dictation is heard, pictures, or even diagrams, are deformed

after a few copyings by hand. It was for this reason that Pliny said in his *Botany* that he would describe plants in such detail as to make illustrations unnecessary. Illustration by hand, moreover, was too slow and costly to help the early pamphleteers.

The first tract printed with a picture portended a change as deep as did the first cannon shot. Picture-printing made it possible to reproduce an illustration indefinitely and identically. It enabled the pamphleteer to drive home his invective with telling draughtsmanship and helped him to project his message across countries and centuries to people who hardly read his language. The political power of pictures can be realized by imagining the *Daily Worker* without its biting cartoons, or the British press without Low's graphic commentaries. Illustrations helped to give Savonarola's and Luther's tracts such force of persuasion among townsmen—sensitized to art by a familiarity denied to peasants—that the ensuing uproar broke western Christendom asunder. It remains to be seen if broadcasting and the atom bomb, the last inventions of the unnamed age that has just ended, will, in the long run, prove more unsettling than printing and gunpowder, the last inventions of the Middle Ages.

Though Savonarola did not live in Florence until he was thirty, preached there for barely thirteen years, and published for only eight, his awareness of the arts as a political force helped him to make an impact on the city almost as deep as Dante's. Even if he had not sensed the power of printed pictures, he probably would have used the press, for priests and nuns had printed and published in Florence almost since printing was introduced there, eleven years or so before he first arrived. But he could have profited by so brief a chance to fasten his hold on that center of the Renaissance only by being an instigator of the arts in general and of book illustration in particular. He started publishing at a happy moment, for his first dated tract appeared in 1491, a year or so after the first book illustrated with a Florentine woodcut had marked the turn in

Florence from costly, limited, and occasional illustration by engravings to the inexpensive mass production of woodcuts. Savonarola's subtle understanding of art appears in many things that he said. Long before Morelli and Berenson, with the aid of modern photography, had popularized the idea of an artist's style as a personal unity, Savonarola realized that "Every painter portrays himself. When he makes images of lions, horses, men and women, he portrays himself, not as a man, but as a painter. However varied his works, each one is stamped by his thought." He showed his awareness of the healthy emotional release that comes from making a work of art by urging some Sienese nuns to illuminate manuscripts and the friars of his monastery of San Marco to work as architects, sculptors, and painters. The ten artists, among them Fra Bartolommeo, who became monks in San Marco during Savonarola's brief ascendency, were drawn there by his rare understanding of their problems. So great was his hold over artists that the shock of his execution stopped Fra Bartolommeo from painting for several years. It was not to destroy art, but to magnetize it toward salvation, that Savonarola's famous carnival bonfires of vanities were heaped with everything from false hair and ivory chessmen to the worldly pictures of Botticelli.

When he preached on the Art of Dying in 1496 Savonarola gave specific instructions for using pictures to a good purpose. The contemporary edition is illustrated with three woodcuts: Death offering a man the choice between Heaven and Hell, Death knocking at a sick man's chamber door, and Death claiming the dying man as he makes a last grasp at salvation. The woodcuts of the pamphlet are drawn to the reformer's specifications to serve as patterns for campaign posters. A good Christian, Savonarola says, should have each of these subjects painted on a paper. "Keep the paper in thy chamber where it be before thine eyes, though not so constantly that seeing it becomes a habit and ceases to move thee. Look closely on this picture to dwell with death; look where thou wouldst go: Up, to Heaven? Or down, to Hell?"

During the decade after he started to publish in Florence, Florentine book illustrations show Savonarola's commanding presence as plainly as his disciple Botticelli's, impossible though it is to document a direct connection of either man with the woodcutters. The partnership of preacher and painter needled the Florentine woodcuts of the 1490's with a young poignancy that is never again so intense in all printmaking. These wonderful illustrations helped to speed Savonarola's tracts to reprints in Venice, France, the Netherlands, and widely in Germany. They traveled so fast that his exposition of Psalm 51, "Have mercy on me, O God," appeared in Latin and German at Alost, Augsburg, Magdeburg, and Nuremberg a year or two after he wrote it in Florence.

Luther said nothing so subtle as Savonarola on the arts, but he regularly used them as weapons for attack. He anticipated the Jesuits in his campaign methods of driving home the word of God "by singing and speaking, rhyming and preaching, writing and reading, painting and drawing." Many of his letters and publications show his grasp of the value of book illustrations for persuasion. While translating the Bible into German he sketched the furnishings of Solomon's temple on the margins of his manuscript and scribbled indications for the illustrator. He even supervised the drawing of the woodcuts to make sure that the artist confined himself to illustrating the text with literal simplicity and with no "schmiren" of any "unnütz Ding." He composed an allegorical frontispiece to set forth the gist of one of his pamphlets, and once sent a friend a woodcut of a satirical coat-of-arms for the Pope, saying "I drew this, or had it drawn for me." Even in the thick of his enormous activity he wrote, "I wish I had time to direct the printers' use of illustrations, type, ink and paper."

Luther probably supervised the illustration of the little picture book *Antithesis of Christ and Antichrist*, printed at Wittenberg in 1521, for he wrote that the woodcuts made "the book good for laymen." The success of these cuts, which are attributed to the leading local painter, Lucas Cranach the Elder, must

A. HYATT MAYOR

have been in Luther's mind a year or so later when he established a press in Wittenberg to publish the good word, for he chose Cranach to run the press in partnership with a goldsmith (goldsmiths often cut type or woodblocks). Luther evidently regarded the painter as more important than the goldsmith, for he constantly wrote to his secretary, "have Lucas print this on his press, which is idle," or "ask my Lucas to send a hundred copies."

Not only did Luther find eager readers for a hundred and twenty separate tracts written in one year, but the Wittenberg presses turned out at least twelve hundred editions of his works during his lifetime—about a third of the total German production of Reformation tracts. It has been estimated that in spite of the sweeping powers of censorship given to the Church by the Diet of Worms, in 1521, Germany printed twelve times more books in 1523 than ten years before. Since three quarters of this huge increase was Lutheran, printers demanded a subsidy for printing anything against the Reformation. Woodcuts certainly played a part in creating such a voracity for pamphlets that the Germans, according to Erasmus, bought only Lutheran books, and in France the Sorbonne, in 1523, petitioned the king to forbid the diabolical art of printing altogether.

The resemblance in format and layout of Savonarola's and Luther's tracts is too striking to be accidental. Either the Italian tracts were familiar enough in Germany to serve as models, or the reformers hit on similar means because both addressed themselves to middle-class city dwellers. Savonarola and Luther, or their printers, knew the basic requirements for getting publications into the hands of busy readers. Their pamphlets measure about the size of *Reader's Digest* or *Coronet* and fit as readily into a pocket. Both display the title plainly on the cover, though with one characteristic difference: Luther's titles ramble down most of the page in several sizes of black letter, for he wrote, as he spoke, in torrents; while Savonarola stated his case in a line or two of plain Roman. He said that "writing is one thing and preaching quite another"; the preacher must expand

to allow for the congregation's daydreaming or forgetting ,while the writer can condense for rereading.

Both reformers enlivened their title pages, and sometimes their back covers, with striking woodcuts. The reappearance of the woodcuts on various works served to advertise the series, like a distinctive cover on a magazine. When anyone saw a familiar cut on a bookstall across the street, or sticking out of a man's pocket, or in the hand of some reader in a tavern or on muleback, he knew that the latest by the Frate or Luther had been put on sale.

The subjects of the woodcuts display differences as characteristic as the typography of the titles. Luther, the rough and ready challenger, decorated his pamphlets with rich borders that often had no connection with the contents—or even with a Christian subject. In the illustrations his raging satire proclaimed his aim as total war for the extinction of the Papacy, root and branch. Savonarola's covers show an earnest woodcut that is eloquent but never satirical. He said that "books should be inexpensive and printed [not written] without illuminations, silken ties, gilt leaves or other decoration. Let them be correct, but not ornate." There could be no better description of the sober elegance and the striking restraint of the Florentine press during its great decade.

Savonarola's cover picture often shows the various ways he chose to give his message to mankind. In one woodcut he is talking with quiet, human concentration to a group of nuns. Another shows him writing in his cell in San Marco—a man who finds himself appointed to be one of the secretaries of the Holy Ghost, who hears God speak to him direct and must therefore transmit God's dictation, direct, to man. Thousands of lives are swayed by this mental voice composing sentences in a room as blank as a broadcasting station. A third woodcut is the best surviving picture of the Frate in action as the dramatic artist of the pulpit. Down the length of the nave a low canvas fence separates the men from the women. Hearers who have been waiting since dawn have packed themselves into the church as tight as in a

A. HYATT MAYOR

subway rush, jamming even the steps to the pulpit. Whoever faints must collapse in a huddle, pressed around by knees. The picture records a clamor and a conflagration that has to this day not quite died down. As late as 1898 the city of Florence hardly dared observe the date of Savonarola's execution, fearing that the martyr's ashes, after four hundred years, were still too hot to handle. This little woodcut, designed to move men to salvation, carries across the centuries a voice no hearer ever forgot, the "viva voce" that continued ringing in Michelangelo's ears even into his old age, years and years after Savonarola had vanished in the flames.

Change and Permanence in Men's Clothes

/——————————————————————————————————————/

The Metropolitan Museum of Art Bulletin n.s. 8, 9

MAY 1950: 262–69

Woodcut on title page of Juan de Alcega, *Libro de geometria*. Toledo, 1589.
Harris Brisbane Dick Fund, 1941 (41.7).

E VERY VISITOR—or at least every male visitor—to the Costume Institute's current exhibition, *Adam in the Looking Glass*, is peppered with questions. Where do men's fashions originate? How much is useful and how much is vestigial encumbrance? Why do men and women today think about clothes so differently? Why have men's styles usually been static except from about 1300 to 1800, when they changed from year to year?

Almost every discussion of men's clothes begins with speculations why they have developed so little during the last hundred years—years that have altered the whole world's way of living more than any thousand years before. It is indeed curious that a woman should feel odd in last year's hat, while a man can wear a suit twenty years old without being noticed, or walk down the street in his grandfather's fur-lined overcoat feeling conspicuous only in being ultra-smart. Indeed, if a gentleman of 1840 should materialize at a formal dance today, his tailcoat and broad shirt front would not look out of place. But of course styles for formal occasions ordinarily survive longest because they depend most on ancestral precedent. The king of England's coronation robes were invented centuries before his old gilded coach first rolled from the carriage-maker's shop, pitching and swaying on its leather "springs." In our naïve surprise at the stodginess of men's clothes today we forget that, viewed in the larger light of history, all clothes have normally been static. A Roman's toga hardly changed in a hundred years, or a pharaoh's dress in a thousand, and Chinese clothes have varied in color and in decoration but hardly at all in cut since time out of mind.

As a matter of fact, the pharaoh's regalia outlasted Egypt's greatness, and the Roman's toga survived in the New Rome on the Bosphorus; for fashions often outlive the civilizations that

they express. Indeed fashions seem to regroup historical epochs in larger units. One sweep of styles flowed from the early Greeks through the high Middle Ages, as the draping of yard goods gradually evolved into long shirts and cloaks that hung almost as simply. During those two thousand years men and women dressed practically alike. (When Achilles disguised himself as a girl, or the mythical Pope Joan as a theological student, their disguise must have felt like their normal clothes.) This long age of epicene dress produced literature that seems to us to ignore the full impact of love on an adult. Love is good for a guffaw in *Lysistrata*, for poetic cerebration in the *Symposium*, for adolescent experiment in *Daphnis and Chloe*. Only Catullus wrote about love as we do, as a transforming obsession, and he died young. With the troubadours and Dante Western man left his family or clan and became an individual facing other individuals. Henceforth literature is double-starred with pairs of lovers: Paolo and Francesca, Troilus and Cressida, Anthony and Cleopatra (a Roman political scandal that the Renaissance transformed into a heroic tragedy of love), the Misanthrope and Célimène, Anna Karenina and Vronsky.

As our modern literature of love emerged men and women discarded the cloaks of the high Middle Ages and began to dress differently from each other for the first time since the Egyptians and Minoans. Man changed from loose chain mail to fitted plate armor, stripped his legs to tights and decorated his torso, while woman billowed out into the flowing skirts of the maternity styles that enabled her to carry on her almost continuous child-bearing unobtrusively. All the quick mad pranks of the next five hundred years did not affect the basic innovation that had begun about 1300 when the *tailleur* appeared to cut (*tailler*) and fit for men, and the *couturier* to sew (*coudre*) and assemble for women.

The new craft of tailoring was resisted by the Greco-Roman tradition of sophisticated draping in Italy, where clothes in the latter Middle Ages and the Renaissance conformed to the body like a glove to allow for muscular freedom. Leon Battista Alberti

A. HYATT MAYOR

would have found it harder to surprise his friends with acrobatic stunts had he worn Northern clothes instead of Italian ones. But French and German tailors, who are said to have been the first to organize themselves into guilds, pinched and padded men like Procrustean despots. Northern jackets and shoes so deformed men's bodies that Vasari blamed Dürer's nudes on his drawing from prentices "who must have had bad figures, as Germans generally have when naked, although one sees many who are fine men in their clothes."

The new styles that exaggerated the difference between the sexes enabled man to express preoccupations peculiar to his masculinity. Caesar had consoled his dismay at baldness by sneaking a toupee, or by shaving his whole head like a soldier in camp who had to reduce the shelter for lice. But now a man wore the most wonderful hats indoors and out, in bed, and before the altar, and dreamed up wigs that became his crowning glory. Tights or stockings allowed him to display a muscular leg, which was so important that Saint Simon rarely fails to note if a courtier's leg was "well nourished" or "dry." Since athletic sports were closed to women until very recently, man also expressed his masculinity by changing from his everyday clothes for violent exercise. While the Greek had simplified matters by shedding everything, the medieval jouster went to the other extreme by encasing himself in a flashing shell of steel topped with plumes.

Our modern idea of sport clothes as something between these extremes—a covering that does not hamper action—seems to have appeared first among the pioneers of handball tennis, who simply stripped off their jackets and put on doeskin gloves as early as 1431 and morocco leather slippers by 1560. But in 1632 water sports still required as fancy a costume as jousts, for the Duke of Lorraine swam in a flowered cotton jacket with elbow sleeves and a broad straw hat completely lined with Chinese taffeta. We have lost a world of fantasy in our plain, specialized uniforms now prescribed for swimming, golf, tennis, dancing, riding, and weddings. The change in clothes has been accom-

panied by a change in the ideal of masculine behavior. In the seventeenth century when men powdered, studied the conduct of a clouded cane, and titivated their curls and their lace, Tallemant des Réaux called a man effeminate for continuing to bathe and exercise daily after he had outlived his good looks.

Medieval and Renaissance clothes not only expressed a man's masculine preoccupations, but also registered his station in life more exactly than before or since. In the settled and stratified society of Europe from the late Middle Ages until the French Revolution state funds were spent by hereditary nobles, who changed fashions quickly for reasons that are clear. When a man ruled because he had taken the trouble to be born a duke, learning to read and write only laid him open to competition from the vulgar without making him one quartering more ducal. How then could he keep ahead when the peasant's toe was forever kibing the courtier's heel? The most conspicuous way to set himself above his imitators was to change expensive fashions too fast for poorer men to follow. For five centuries the nobles led a hare-and-hound chase by discarding fashions that were then picked up by all and sundry. Sumptuary laws merely stimulated the pursuers by teasing. In 1617 Fynes Moryson said: "All manner of attire came first into the city and country from the court, which, being once received by the common people, and by the very stage-players themselves, the courtiers justly cast off, and take new fashions." Even Philip Stubbes, in his violent *Anatomy of Abuses* of 1583, sourly allows a certain license to the courtier by saying of expensive shirts, "If the Nobilitie or Gentrie onely did weare them it were somedeal more tollerable."

The courtier could also distinguish himself by wearing clothes too awkward for a working man, such as boot tops so wide that he had to walk straddling, or shoes with points two feet long. Some of the seventeenth-century French styles were not only cumbersome to wear but required an expert valet to tie up the dozens of points, or laces. When a suit had five hundred and seventy-six buttons most were probably ornamental, but some

A. HYATT MAYOR

must have needed a good deal of time to do and undo. And a man certainly could not dress himself alone in clothes that rustled with bowknots tied from over three hundred yards of ribbon. Such extravagancies might have led Pascal, had he respected order less, to anticipate Veblen's theory of conspicuous waste. He went as far as was possible for a seventeenth-century Frenchman by saying:

> To go bravely dressed is not all vanity, but a manner of showing that many people serve a man who shows by his hair that he has a coiffeur and a perfumer, and so forth. Now it is not a mere external or trinket to command many hands. The more hands a man commands, the more powerful he is, so to go bravely dressed is to display one's power.

But the courtier's policy of inimitable whim found a counterpoise in the professional man's resistance to innovation. For there is no doubt but that professions stabilize fashions. The soldier, the butler, the sailor, the monk, the judge, and the priest have always distinguished themselves from the rest of men by conserving fashions that were discarded by the world of elegance as long as a thousand years ago. A practiced eye can pick out the banker, the artist, the traveling salesman, the professor, and (though he does not think so) the detective. In any society that is governed by officials, like ours or that of Rome, Egypt, and China, men are bound to dress traditionally. Because no man is born a judge or a priest he celebrates achieving such status by doing all he can to identify himself with his fellows and predecessors.

Long after ecclesiastics had standardized their clothes Louis XIV's soldiers followed suit when the rich and centralized government of France began to equip and pay for a standing army. The uniformity that was first imposed on the foot soldier has gradually crept up the ranks until today only generals enjoy the quaintness of a sartorial license. When a standardized secular dress was still a new idea for laymen, Charles II decided to adopt, and thereby launch, a fashion that he promised never to alter. He did this a few weeks after the Great Fire of London in

order to save his subjects' money, at the very moment when Louis XIV, with a power unhumbled by revolution, was forcing his nobles to ruin themselves by wanton expenses. On October 15, 1666, Charles II appeared in a black and white suit that is said to have established the combination of trousers, waistcoat, and jacket that has prevailed to this day. When Pepys first wore the new style three weeks later, he makes one feel the embarrassing strangeness of it by saying, "Was mighty fearful of ague, my vest being new and thin, and my coat cut not to meet before upon my breast."

Keeping warm was a problem that our central heating has let us forget. Indoor and outdoor dress were more alike when breath fogged in the snuggest room and Louis XIV's water froze on his table. Then, as autumn chilled into winter, a man simply added shirts and stockings until he was wearing up to a dozen of each, and often needed his cloak, gloves, hat, and muff indoors more than out. Today men dress the year around as though they were outdoors in October and women as though they were indoors in August. Winter and summer, men's clothes differ little in weight and not a bit in cut, until habit makes them like a daytime skin. A woman, on the contrary, is reminded of her clothes as often as she changes from short skirts and long sleeves in the day to long skirts and no sleeves at night. Frequent contrasts of weight and constriction make her more willing to experiment with entirely fresh forms. Thus we have the new anomaly of the unchanging man and the inventive, ever varying woman. Or is it so new? Roman women, after all, dared vary more than Roman men by curling up architectural coiffures and showing themselves in oriental silks from which half the threads had been pulled until the flimsy rest clung to the body like net. They could be inventive because they lived with independent means in a society governed by professional men, where most of them by being women escaped from professional categories. This is also true of modern women.

Modern man's drabness of dress has antecedents in the tradition of wearing black. In the early 1400's the Burgundian

A. HYATT MAYOR

court seems to have begun the wearing of black for distinction. Charles the Bold, the richest and most sophisticated prince north of the Alps, posed for Roger van der Weyden in plain black velvet, with no jewel except the collar of the Golden Fleece and no rings on the hand that grasps a wooden dagger handle. From Burgundy the wearing of black passed to France and to Spain, reappeared in Rembrandt's sitters, and has been permanent in Calvinist Switzerland. England, being outside the orbit of Burgundy and the Hapsburgs, took less kindly to black. Charles II soon abandoned his black and white economy fashion because he disliked seeing his courtiers look "like magpies." And yet black is supposed to have been established as obligatory for men's formal wear by Bulwer Lytton's *Pelham, or the Adventure of a Gentleman*, published in 1828, which "recommends dark as safest" for men's clothes and specifies "a white waistcoat with a black coat and trouzers, and a small chain of dead gold, only partially seen." Social fear had come to stay.

It is odd that trousers should now stand for man's timidity in dress, for two thousand years of wear by northern hunters and tribesmen formerly associated them with roughness and revolution. Scythians and Persians were wearing them by 400 B.C. About 120 B.C. Caesar's soldiers adopted them from the region around Narbonne in southern France, which they called Gaul in Trousers (Gallia Bracata), and Scandinavian peat bogs have preserved them to this day on medieval corpses. In 1742 wide overalls were worn by men who rode post into the north of England in order to protect themselves from the mud and cold. The old example of sailors' trousers and of Indians' leather stockings was familiar in America in 1778, when Lord Carlisle wrote home from the Delaware in June: "The gnats of this part of the river are as large as sparrows; I have armed myself against them by wearing trousers, which is the constant dress of this country." In 1809 another Englishman described a man as "dressed in the American style, in a blue suit with round hat and pantaloons."

The Gallic origin of trousers and their association with ple-

beian labor made them a French revolutionary symbol of opposition to courtly knee breeches and powdered wigs. In the 1790's the "Gallic" trousers and the wild "Brutus" haircut were (like the recent black shirts and brown shirts) a political kind of fashion that woman, as a less political animal, has rarely adopted. Trousers and cropped hair denoted radicalism even outside France. In 1791 Walpole heard that eight smart young Englishmen who had cut their hair and discarded powder thought themselves "not fit to appear so docked" at a Windsor Castle ball. Madison and his cabinet in knee breeches were opposed by Americans in pantaloons who combed their hair forward "as though they had been fighting a hurricane backward." In 1812 trousers still had such disturbing connotations in England that two Cambridge colleges ruled to count as absent any undergraduate who presented himself so dressed at hall or chapel. Yet two years later the soldiers returning from Waterloo had made trousers fashionable among civilians, and soon they became as deeply identified with the forces of reaction as the very bourgeoisie that had won the gains of the French Revolution.

Men have certainly dressed timidly since the French Revolution broke the self-confidence of the hereditary nobility and gave their vested power to whoever could seize and hold it. A modern man whose power depends on money or a job knows that it is here today and gone tomorrow, whereas a noble in the old stratified monarchies relied on a power that was as permanent as his name. Louis XIV, as the apex of European society, had the assurance to dazzle some oriental ambassadors by wearing cloth of gold with 14,000,000 francs' worth of diamonds on his hat, coat buttons, rings, garters, shoe buckles, cane, and sword, in a vestment so ponderous that he had to change after lunch. Should we today make the most modest display, we would fear punitive taxes and righteous publicity and be as embarrassed by confessing to class distinctions as our great grandparents were by sex. As Isaac Walker, the New York tailor, wrote in 1885, "It is becoming more and more difficult to assign

A. HYATT MAYOR

a man his place in society on the evidence of his costume, and this state of things will last for a long time to come." And last it will as long as our uniform makes the rich man comfortable in inconspicuousness, the poor man happy in looking like the rich, and all of us able to duck the vexing question of where we belong in the social jumble. The dominant class will innovate fashions, as always—which means, in our century of the common man, that the poor legislate for the rich. Thus reforms in dress will come from the same level as reforms in spelling—not from the benevolent inventors of Esperanto, but from road signs saying THRU HIWAY SLO. The day laborer has already given his blue shirt to the chairman of the board, and the street cleaner his comfortable cottons to the whole city in summer. We will add these gifts to our caddis-worm case of vestiges—the sleeve buttons, the trouser cuffs, the vent at the back of the jacket, and the whole lapel with its nick and button hole—and we will conserve them as peasants used to conserve the courtiers' castoffs. After all, who cares where fashions come from, what they look like, or how they feel or fit, just provided they comfort us with an assurance of correctness?

Alive, Alive, O

The Metropolitan Museum of Art Bulletin n.s. 11, 6
FEBRUARY 1953: 164–67

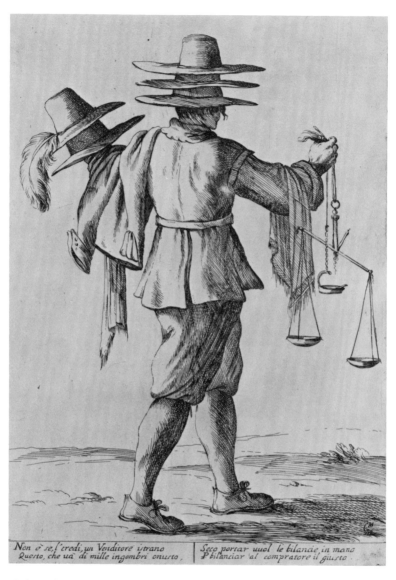

G. M. Mitelli, after Annibale Carracci. "Old Clothes Peddler." Etching
from the series *Di Bologna l'arti per via*, 1660.

The Elisha Whittelsey Collection, The Elisha Whittelsey Fund, 1951 (51.501.3632).

I F WE COULD spend a day in eighteenth-century Paris or London or Philadelphia, we would probably first be struck by the difference in clothes. But almost as soon as our eye had noticed the wide bright skirts, the wigs and embroidered coats, and the contrast between rich and poor, our ear would mark as great a change in sound. Instead of today's motor traffic that roars with the monotony of a waterfall we would be assaulted by a rich clashing of noises from drays thundering over the cobbles and from the more delicate axles of the chaises rattling as horses' hoofs irregularly struck the stone. At intervals, the jumble of din would seem to sink while some peddler's brazen throat and leather lungs bawled from street to street, like an operatic aria evolving out of the orchestra.

Our southern ports still hear an occasional call of "catfish" or "old clothes," which gave Gershwin a picturesque note for *Porgy and Bess*. Even in the North a last cry echoes now and then when a newsboy bellows "uxtree, uxtree" and then gargles alarming vowels. But what is the use? His sensation is no longer salable, for the news has reached every home by radio a good hour before. The newsboy's cry must be the oldest surviving city noise—even older, perhaps, than draft horses and wheels. The cry must have sounded the same when peddling figs in Athens or bullrushes in Babylon, for the hawker can only make himself heard by prolonging all vowels until every language sounds alike. An old Londoner listened to the melody, not to the words, to distinguish between "Round and sound, fivepence a pound, Duke cherries" and sweet Molly Malone's "Coccles and mussels, Alive, alive, O."

Now that the street trades have almost all hidden indoors we forget how these humble ambulants once divided themselves up into classes. The peddler (from *ped*, a basket) carried small

wares himself, like the French *colporteur* (from *col*, neck, and *porter*). He specialized in light articles such as ribbons, pamphlets, and ballad sheets, rings, scissors, and shoe buckles. The huckster or hawker (from the Low-German *hocken*, to carry on the back or to squat) was a step higher because he had either a wheelbarrow or a donkey cart. The costermonger (from *costard*, an apple, and *monger*, dealer) hawked fruit and vegetables.

Before the days of buses, when wet filth lay thick on city streets, the hawker who brought the housewife's needs right to her door also entertained her with the gossip that he had picked up here and there. A London writer in 1650 said, "A peddler first fills his pack with reports and rumors, and then goes peddling up and down." This baggage of tattle must have been particularly relished in Italian towns where the various parishes lived so separately that they quarreled like distinct villages. The peddler's free commodity of news eventually made him one of the most active booksellers to the poor and the half-educated. By taking his booklets direct to his customers' doors, the peddler in France also escaped the police, who strictly controlled bookstores. The French law struggled in vain for years to prevent itinerants from hawking indecent or seditious pamphlets.

Northern Italy engraved some of the first prints of itinerant tradesmen in the later 1400's. Then about 1600 Annibale Carracci drew the first extensive series of studies, which were copied in etchings—first in 1646 and later in 1660 as "the trades that go through the streets of Bologna." This first set of street cries was imitated all over Europe for two centuries, until the last echo of it may be said to have died away in the 1890's in Phil May's drawings of London flower girls.

The various sets of cries often give the most vivid pictures of life in the slums of the various cities. In "fat Bologna" Annibale Carracci's set shows over a third of the peddlers selling food and drink. In Venice, Zompini's set includes a canal dredger, a buyer of broken glass to feed the Murano glass furnaces, and a link boy to accompany returning opera-goers with a lantern lest they step off the unbalustraded bridges into the black water.

A. HYATT MAYOR

There is also a poor busy jobber who offers to regulate sinks, tinker pans, wire broken earthenware, and castrate cats. In Bouchardon's set hawkers of food are scarce because the Paris markets were so well supplied and organized.

The recent disappearance of street cries is but one more sign of the far-reaching change that machinery and mineral fuels have brought to the world. The human voice, which dominated city life from its beginnings in Chaldea until the automobile, must now give way—for who knows how many thousand years—to the beat of the machine.

Does Your Art Collection Express Your Community?

First given as an address to the 1963 convention of the American Federation of Arts.

American Federation of Arts Quarterly 1, 3
1963: 85–92

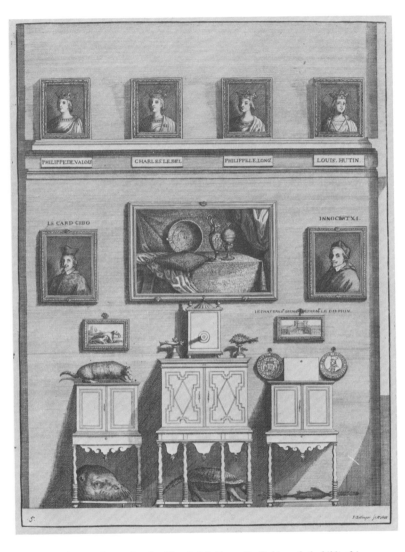

Franz Ertinger. Engraving in Claude Molinet, *Le Cabinet de la bibliothèque de Sainte Geneviève*. Paris, 1692.

A. Hyatt Mayor Purchase Fund, Marjorie Phelps Starr Bequest, 1981 (1981.1119).

THE ATTACHMENT of the museum to its native soil and its home problems provide shadows that set off the brightness of the solid gold highlights of these sessions. Self-help is the opposite of government subsidy. But while we may yet consider ourselves to be on the subject of government aid, I do want to throw in my two cents' worth of enthusiasm for government subsidy *and* government control. The French have had it for three hundred years, since Colbert started the system in the 1660's. They are the past masters of state control of the arts. They have been commissioning operas, training actors, singers, and artists the way the government thinks they ought to be trained and have been commissioning works of art and, in general, directing everything. It has been, I think, a vast success. State support enabled Molière's troupe to perpetuate itself to this day. The state built most of the great buildings around Paris, including the French Opera House itself, the grandest and most festive theater in the world. But I think that the great value of French government patronage has been that after the first couple of decades, the system has never failed to anger lots of people. The Impressionists could never have achieved the unity, the enthusiasm, the power they had unless they had been really riled up by the academies, and I fully expect that our government's greatest contribution will be as an opponent. Even though they order these things better in France, our government will, I hope, also provide a stimulating something for the artist to rage against.

I have been looking over the various museums in this country to see how they are attached to the ground out of which they have come, and the results have been interesting. We, in our museums, have a very different problem from the people in museums abroad. Abroad, the collections are given. Most are

what we would call historical societies. They have been deter-
mined by local accidents, and there is not much that anyone
can do about them. The Uffizi, for instance, really consists of
the household gear of the Medici family, plus a few things lifted
out of parish churches. They are the things that were created by
the Medici servants and it just happens that among the Medici
servants were Botticelli, Michelangelo, and a few people like
that. So the Uffizi remains as a sort of vast durable jam closet
of all the goodies that the cook has put up over the summer, and
we are here, now, to enjoy the products of this wonderful Medici
household. The great armor collections in Schloss Ambras and
in Vienna and Madrid are really nothing but the old clothes
of the Hapsburgs, or rather that part of them that the moths
couldn't munch on. If the Medici had clothed themselves in
steel, instead of in the wool that they bought from Flanders,
dyed, fulled, and then sold back to Flanders, if they had dressed
themselves in something more durable, we would have as many
personal mementos of the Medici. Today so little is added to
these glorious ancestral leftovers that their curators can concen-
trate on installations that are often more ingenious than ours,
and can write definitive catalogs. Now that the pace of our col-
lecting is slowing down, we must turn our attention to publish-
ing what our predecessors have gathered.

We Americans were shown our direction by the earliest
modern trends in European museums, first by the National
Gallery in London shortly after 1800, then by the Victoria and
Albert Museum after the great exhibition of 1851, and finally
by Bode's work in the Kaiser Friedrich Museum in Berlin.
Here were museums founded on a new principle. Here were
collections bought with government funds in order to represent
the arts of nothing less than the world. The Victoria and Albert
Museum was founded in order to lend works of the decorative
arts of the past which might improve the taste and quality of
contemporary manufactures. Of course, that was in those inno-
cent days when people thought that the study of the past
strengthened, instead of squashed one's individuality. The

A. HYATT MAYOR

Victoria and Albert Museum set out to represent the arts of the world and so did the National Gallery and the Kaiser Friedrich Museum.

We inherited the pattern of universality achieved by purchase. Therefore, we bear the burden, the almost intolerable burden, of freedom, and are handcuffed to liberty. Now of course, we are all on the side of liberty—she is a nice girl—but she can be an embarrassing wanton at times, and she leads us into difficult decisions. Liberty of selection has given our collections a variety which astonishes the European visitor, who does not expect that a smaller town should have samples of all sorts of things from all over the world and from all of the ages as you have right here in this museum. Our American liberty means that you have to think through a lot of things and are saddled with the embarrassment of choice. To add to our difficulties, this continent faces two oceans, so that we are concerned with the Far East as well as with Europe and the Near East. Comparatively few continental Europeans care much about the Far Eastern art. Europe has no very great collections of the art of the Far East; they are in this country and in the Far East itself. So that adds to the enormousness of the field that we have to do something about.

Our museums have been shaped by the most adventurous spirits of their localities. We have not chosen to follow the taste of everybody, but to follow the taste of a few people who have been at the forefront of thought and of investigation, and we have assumed that everybody else would follow along in time— and they have. So that, in a certain sense, our museums, even our general and our universal museums, are very much attached to the intellectual life of their towns.

Boston was the home of the Universalists and Transcendentalists who equated all religions, who read, along with their Bible, the Vedantas, Confucius, the Mahabharata, and the Koran. They plunged into the Far and Near East, into the Greek world of Plato and Aristotle. So naturally one of the great collections of Greek and Roman things is there, one of the great

collections of Indian things, Chinese things, and the greatest collection of Japanese things outside Japan. They would never have come to Boston and Cambridge if this intellectual interest had not preceded them in the very advanced and remarkable Bostonians of the nineteenth century.

The same sort of local interest created the Metropolitan Museum in New York. The Dutch, who founded the town, came to the island to trade in furs, to make money, and to enjoy themselves with their gains and that quality—irreligious enjoyment—has persisted in New York City. So the American Wing today does not represent the great North American religions that have created works of art, shows no work by the Penitentes, and little by the Shakers. This secular approach, despite the splendid and decorative exception of the Cloisters, is unlike Boston, where the approach is not necessarily Christian, but is certainly theological.

In 1700, New Yorkers talked in a hundred languages, which of course, in those days included various African dialects, that are no longer spoken there. But Manhattan Island must speak at least a hundred languages today, for it has always been a great port with a flux and re-flux of people from all over the world who got on together as best they could. The enormous complexity of interests in New York requires a museum that can answer a really incalculable diversity of questions. A collection so varied is cared for by the most international group of curators that there is anywhere. Unlike the Uffizi, where there are only Italians, or the Louvre with practically nothing but Frenchmen, we have Frenchmen, Spaniards, Italians, Chinese, Germans, Englishmen—we have learned people from all over the world.

Variety makes the fascination of working in the Metropolitan. For thirty years I have been happy to live in this unique polyglot society, and when I retire in 1966, I won't miss the work, for I will get lots of other work. I won't miss the collections, because I can always come in and look at them. But I certainly will miss sitting down to lunch every day in this absolutely

A. HYATT MAYOR

astonishing village. It is these people who have made the Metropolitan the museum that it is.

The universality of the Metropolitan Museum is essential to New York, but would be superfluous in most other places. So it is unfortunate that the Metropolitan should have become a model for so many other museums. With this in mind, I have been considering the various museums that are here and there to see how they are attached to their localities. It seems to me that possibly in the West where we are now, there is a greater awareness of things made in the locality and of the life of the locality than there is in the East. There is the Amon Carter Museum with the Russells and the Remingtons. Then in Colorado Springs there is that marvelous, unique collection of bultos and santos, where Spanish mysticism dies in a far desert with an agony as intense as its start in Saint John of the Cross. In Seattle there is that remarkable series of work of the Indians of the Northwest, treated not as ethnology but as works of art. And in San Francisco there will soon be a great collection of Chinese things where it is deeply needed by the greatest concentration of prosperous and intelligent people of Far Eastern descent that lives anywhere outside the Far East. Up to now they have had nothing to show the greatness of the art of their various homelands except what you find in Chinatown. At last they will have a worthy reminder of their greatness.

Various remarkable museums owe their being to the enthusiasm of one individual. I think, of course, of the great Indian collection, the superb collection of Chinese paintings in Kansas City, that Mr. Sickman got together—or the comprehensive review of Spain that Archer Huntington created in my own Hispanic Society. One thinks also of the great collection at Winterthur that Mr. Du Pont made by his own personal effort, and placed in a region where people respond to that kind of thing. In Hartford Everett Austin got together that pioneer collection of baroque painting. And in Sarasota he continued and perfected the work of Mr. Ringling, who had instructed himself with a remarkable ability for self-education. Mrs. Whitney's interest

in American painting has resulted in a formative center for our art.

There are other museums that have gained by specializing. When the Brooklyn Museum was founded as a sort of defiance of the Metropolitan, they set out to do something the Metropolitan was not doing, and very intelligently they did it too. They now have the only good collection of Colonial Latin American art north of the Rio Bravo, and it is the only general collection of colonial things from all over Latin America in the whole New World. The intellectual interests of the Latin American Republics find their meeting place in this country. From here only does one survey the art of the entire continent, and look at the whole range of everything from the Mexican border to the Tierra del Fuego, so that the Latin American collections in the Brooklyn Museum perform a unique function. Brooklyn also realized what the Metropolitan did not realize in 1872, at the time of its foundation, that the arts of Oceania, Africa and pre-Columbian America were art, and not just ethnology.

Who could then have foreseen that they would become one of the great forces in art today? I hope that the Metropolitan can some day follow Brooklyn's example by putting together a token showing of those anything but "primitive" things, just to complete our visual history of man.

Some of the most interesting American Museums are trade museums; the museums that attach themselves to a local activity. They are all over the place, and are extremely varied. The great collection of decorative art at Cooper Union, for instance, was gathered by the Hewitt sisters in order to provide models for training designers and artists. They planned a kind of Victoria and Albert Museum to serve the Cooper Union School. Since New York was at that time the center of design in the United States the Museum was definitely attached to a great trade interest. Other collections created by vanished industries are the Peabody Museum in Salem, with its romantic souvenirs of American sails in the Pacific, and the lively Circus Museum in Sarasota, the only reminder of the winters when the sunny

A. HYATT MAYOR

little town used to be knee-deep in midgets. The Textile Museum in Washington is not in a textile center. In 1890 one would have expected a great textile museum to arise in Fall River, perhaps. But now that the Fall River and the Massachusetts mills are given over to rats and gulls and the windows broken in dilapidation, I really don't know where the center of the textile industry may be. So the Textile Museum might just as well be in Washington as somewhere else.

There are even more specific alliances. For instance, the comprehensive collection of photography at George Eastman House in Rochester. This is not only a museum attached to an industry, it is a museum created *by* an industry, and paid for by the Eastman Kodak Company. And the result has been a unique center to which one must go to see the technique, the art, or the history of photography. In an equally outstanding trade museum the Corning Glass Company has assembled a great collection of glass, not to push their own products, but in order to show the history of glass back to the very earliest ages. Like George Eastman House, the Corning Glass Center has taken the next step by publishing their sumptuous annual called *Glass Studies*, which is the only magazine in the world that is devoted to the study of old glass, its design, and its technical aspects. It does for glass what the great Italian annual called *Faenza* does for pottery and porcelain. *Faenza* is published by the museum in Faenza itself, with funds from the Italian government that make it as luxurious as *Glass Studies*. Eastman Kodak and Corning Glass, like many Italian industries, have realized that the most durable advertising comes from subsidizing well-written books that need not have any direct connection with the business.

I hope you won't misunderstand me if I include among these trade museums the Museum of Modern Art in New York. After all, painting and sculpture are one of the specialties of Manhattan Island, just as they are of Paris. The Parisians, being more expert in *les arts publicitaires*, realize much better how to put across their important product. They print posters so vivid that

if you look at the billboards in Paris, you think that nothing goes on there except art shows. New York galleries, except for Terry Dintenfass and a few others, have not yet realized that their most effective public gesture would be to make posters worth collecting. If they did, we would all then be aware that art is a heavy industry in New York. The Museum of Modern Art derives its living quality from its contact with this enormously vivacious and fascinating occupation of the island.

Now, what more is to be done? What is lacking? What specialties are still looking for their museums? I can think of a few. There is no museum for pottery and porcelain, the way there is for glass. In pottery and porcelain you would expect perhaps the manufacturers in Trenton, Syracuse, or the Carolinas to take up the matter. There should be some museums that really go into the matter technically, artistically, geographically, in every way. It would not be beyond the means of a healthy industry, and it could still be done, which is important. If you were going to make a collection of Italian drawings now-a-days, you might as well say good-bye to the idea of getting Leonardos, Michelangelos, and Raphaels. But if you are going to make a collection of pottery and porcelain, I think you could get examples of practically everything, including the Medici porcelain, if you weren't in a hurry about it. Then there is no really good museum of the railroad. One would think that possibly some sort of a great nostalgic iron cavalcade could be assembled in Chicago, the rail center of the United States. There are a lot of documents on the railroads, all the Huntington archives about putting through the trans-continental railroad are in the Hispanic Society, and available to any museum that sets itself up seriously to do the railroads.

There is curiously enough no really great museum of the theater. That, I suppose, should be in New York. That curious citadel of power in Lincoln Center would be the place for a great, a really great museum of the theater and of opera, which could be put together out of various collections on Manhattan Island. In Los Angeles, as far as I know, there is really no good

A. HYATT MAYOR

museum of the movie, though that is done well by the Museum of Modern Art in New York.

The upshot of all these remarks is merely a plea for specialization and intelligent regionalism. Specialization pays, for few can keep up the war on all fronts at once—not even the Metropolitan, not by a long shot. And if, in a smaller place, you concentrate your fire, if you design something for some particular specific purpose, preferably to answer a local interest and activity, then you create that better mousetrap to which all the world will beat its way.

Artists as Anatomists

The Metropolitan Museum of Art Bulletin n.s. 22, 6
FEBRUARY 1964: 201–10

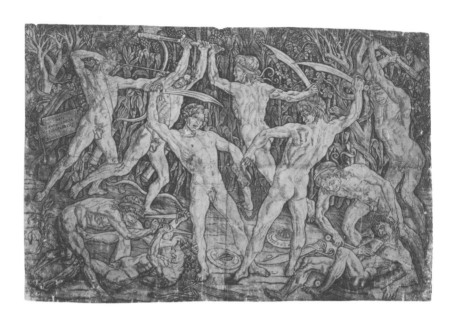

Antonio Pollaiuolo. *The Battle of the Ten Naked Men*. Engraving, late 1460s.
Purchase, Joseph Pulitzer Bequest, 1917 (17.50.99).

I N CHINA AND JAPAN, artists are judged by the various ways in which they paint mountains, pines, or carp; it was the egocentric Greeks who taught the West to judge artists by their ability to draw and model the human figure—especially the nude. Western artists since the Renaissance have represented the nude in two distinct manners: either with surgical particularity like Géricault and Eakins, or else according to a generalized scheme like Boucher and Ingres. Both of these approaches originated in Renaissance Italy, and both first became public property through celebrated engravings.

The detailed and surgical approach derives from the study of dissected cadavers, as practiced in recent times by both Géricault and Eakins. As early as the 1300s Italian artists could have seen anatomical dissections in the cold of carnival time, when holiday-makers paid the pennies charged for any sideshow to watch a barber-surgeon anatomize while a professor read aloud from a textbook. The Italian artists who were studying to represent the nude quickly discovered more than all the doctors about the shape and functioning of bones and muscles. Their purpose disregarded the viscera, which the physicians concentrated on in searching for the seats of illness. Artists nonetheless observed more sharply than doctors because you do not begin to see a thing until you draw it. Lynn Thorndyke has aptly remarked in his *History of Science* that in the Renaissance "sculpture and painting were more exact and interesting pursuits than physics and chemistry." Art and science, far from clashing, joined to study the visible world, for science needed the artist to draw and so communicate his observation to others, while art needed the scientist to explain God's handicraft, which artists wished to represent in all its clarity.

Thus the sculptor Lorenzo Ghiberti, writing in Florence before 1448, says that a sculptor must have watched dissections

("haver veduto notomia") to learn the bones, muscles, tendons, and ligaments. He then bursts out: "O most noble! Without knowing the bones in the human body no one can shape a manly statue." (It strikes us as odd today that Ghiberti should not mention a woman's statue, and seems never to have made an important one, but his reading of antique literature probably persuaded him that man was the fairer creature.) Venetian artists also watched dissections, for one of the best of them (Gentile Bellini? Carpaccio?) drew such a scene from direct observation to make a woodcut in 1493 for the first beautifully illustrated medical book.

The earliest artist who took up the knife himself was Antonio Pollaiuolo, who, Vasari says, "skinned many human bodies to study the anatomy and was the first who thus investigated the action of the muscles in order to draw them correctly." Pollaiuolo ran the most enterprising artistic workshop in Florence, which turned out altarpieces, frescoes, panel paintings, bronzes, jewelry, designs for marquetry and embroidery, and crosses and other things decorated with engraved silver plates. The shop's only printed engraving that can be attributed with certainty is one mentioned by Vasari, labeled OPUS ANTONII POLLAIOLI FLORENTTINI ("Made by Antonio Pollaiuolo the Florentine"; to translate still further, *pollaiuolo* means "poulterer," from the artist's father's business). This print, known as the *Battle of the Ten Naked Men*, probably dates from about 1460 and is the earliest large copperplate engraving.

It is also the most influential print ever published in Florence, for it provided the first printed repertory of the muscles. It made history because it crammed a whole course of figure drawing onto one piece of paper, in a scrimmage of fighters stooping, reaching, striding, and striking, viewed from both front and back. But these ten men, though they move too briskly to represent dissected cadavers, are stripped beyond nakedness. If not flayed, then their skins must be transparent to reveal all the muscles and sinews that Pollaiuolo crowded into them, regardless of which would flex for such actions and which would not.

A. HYATT MAYOR

Leonardo da Vinci was probably thinking of this famous engraving when he wrote that a good painter must know what muscles swell for any given action, "and must emphasize the bulging of those muscles only and not the rest, as some painters do who think that they are showing off their skill when they draw nudes that are knotty [*legnosi*] and graceless—mere sacks of nuts." But Pollaiuolo the didactic illustrator drew differently from Pollaiuolo the painter, who knew magnificently how to select and suppress for dramatic effect in *Hercules and the Hydra* or the *Martyrdom of Saint Sebastian.*

In the engraving Pollaiuolo deliberately surveyed the whole equipment of muscles to provide a syllabus for teaching. He dissected to uncover man with the eagerness of the navigators who were then exploring the shores of the expanding world. The two great ages of anatomical discovery, in Renaissance Italy and in the medical school at Alexandria, correspond to the two great ages of geographical discovery, through the Renaissance voyages and Alexander's conquests. These were also the two inventive ages of erotic art in the West, for happy findings inspire a hopeful curiosity about everything. (One may add that today, as we launch ourselves into outer space, we also are penetrating the microscopic functions of the body and groping into the cryptic energy of the emotions.) Leonardo da Vinci likened an anatomist to a geographer when he proposed to demonstrate man's body "on the same plan as Ptolemy's cosmography." Pollaiuolo was charting nothing less than the totality of man's muscles at the same time that Italian cartographers were trying to map the daily explorations of harbors and rivers that had never seen a sail. Both anatomist and cartographer felt obliged to fit the complete crop of discoveries into their pictures of the geography of man and the anatomy of the earth. The products of this enthusiasm, the *Ten Naked Men* and the maps engraved in Rome and Bologna in the 1470s, mark the first time that the thirty-year-old technique of printed engravings was used not for amusement or moral edification but for the propagation of knowledge.

How did Pollaiuolo record his dissections? Not one anatomical drawing by him seems to exist today—not even in a copy—though you would think that he must have made hundreds to plot the muscles in such detail. There is a chance, however, that he may not have drawn at all, but, like a proper sculptor, modeled dissections in wax. Now, if he copied all the dissected muscles in a wax model and then engraved his *Ten Naked Men* from the wax figurine, every muscle would appear in the engraving whether the body's action required it or not. And if he bent his wax manikin into a pose that he then engraved from both sides, he would come out with the symmetrical clash of the ten strange combatants, who face each other like five men attacking a looking glass. The notion of modeling dissections in wax could have been suggested by a remark in Pliny's *Natural History* (xxxv), which all educated men read in the Renaissance. Pliny says that the Greek sculptor Lysistratos "was the first to reproduce the human form by molding plaster on the body itself, then pouring wax into the plaster mold, and retouching [the wax cast]. He was the first to get exact likenesses instead of beautifying." You would think that Pollaiuolo, a sculptor as well as a draughtsman, might have found his muscle man useful enough to warrant the cost of casting it in bronze. If he did, no trace of it exists today, though less than a century later bronze muscle men were in every studio. On the other hand, Pollaiuolo might have got more use out of a manikin in wax that he could bend into various poses. Such a manikin would explain the identity of pose of the engraved naked man at the left and the Hercules of 1460. Which came first? Did Pollaiuolo find a wax model so convenient for painting the Hercules that he helped other artists by putting it through its paces in the *Ten Naked Men*? Or the other way around? We will never know, but certainly years later, in 1475, when he and his assistants painted the *Martydrom of Saint Sebastian*, a manikin must have been bent in three poses, and each pose painted from two aspects to assemble the symmetrical ring of six archers who circle around the saint.

Had Pollaiuolo made drawings of dissections, he could have done so from a body laid out on a table, but if he modeled, he would have had to study the body all around by hanging it from a beam, as it hangs in an engraving of a century later. This engraving shows one wrist tied to the neck in order to expose the whole rib cage on one side. If the wrist were to be tied to another beam, it would not only show the rib cage but would also keep drafts from revolving the body as the artist modeled. Either suspension would raise the arm in a gesture of entreaty or command, or that of a man about to strike a blow, which is the basic gesture of the *Ten Naked Men*—and also of every sculptured muscle man from the earliest right through to Houdon's. Houdon's muscle man, the most famous of all, started as a study for Saint John the Baptist raising his hand to command attention as he preaches.

Pollaiuolo's swoopstake agglomeration of the muscles might have confused more than it clarified if it had not happened that, at about the same time, Andrea Mantegna engraved several nudes whose formal construction established a lasting model. Mantegna, working in the north Italian homeland of the first archaeologists, revived the simplified, balanced, and grand anatomy of antique marbles from their thousand-year sleep. He may never have seen a real Greek sculpture, but he owned bits of Roman copies. The Romans did not, like us, reproduce statues accurately by direct bronze casts. Instead, they made plaster casts of the originals, which they copied in marble with a triangular pointing machine. Even when the copyist worked down the marble with points set close together, he still smoothed over delicacies of transition and trembling irregularities between the points. A good Greek original sculpture delights by being unexpected and alive, but the impersonal simplification of the Roman copy teaches a plainer lesson. So it may be lucky that Mantegna studied Roman copies instead of Greek originals because the copies gave him a diagram whose rational simplification projects at a distance like an actor's mask.

Mantegna's complete, ready-to-wear anatomical scheme

organized the body with a logic whose classicism inspired Dürer, Raphael, Poussin, Ingres, Cézanne, and Léger. Pollaiuolo started artists on the lonely drudgery of dissection, on a confrontation with nature that led to more diversity. Out of this solitary labor came Leonardo da Vinci's exquisite swift drawings of dissections that unsurpassably combine the illusion of appearance with the intellectual analysis of a diagram. Out of it came also the brute impact of Caravaggio and Géricault, Eakins's remorseless steadiness of gaze, and Francis Bacon's tangle of tendons.

Some artists have combined both traditions, as Houdon did when he fitted what his surgery discovered into the grand scheme of the antique. But as long as man holds the center of the stage in the West—and can he bow himself out for keeps?—artists will remember the lessons engraved by Pollaiuolo and Mantegna.

How to Bake an Exhibition

Photography in the Fine Arts Bulletin
FALL, 1964: 3–10

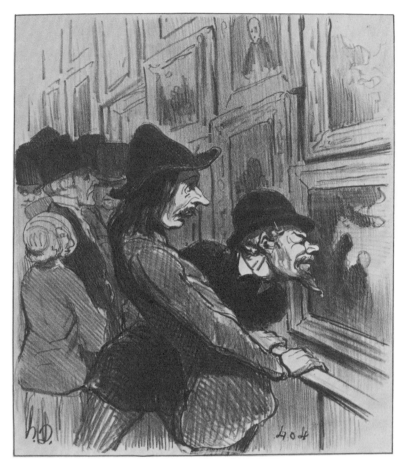

Honoré Daumier. "Artists Examining the Work of a Rival." Lithograph
published in *Charivari*, 1852.

Rogers Fund, 1922 (22.61.92).

ALL OF US who work in museums are often asked how we set about composing a special exhibition. What makes a show interesting? How do you arrange it? How do you attract people into the gallery and, once in, get them to look? So it might be useful to throw together a sort of cook-book recipe based on some thirty years of trial and error.

The basic ingredients for a tasty exhibition—the soup stock out of which it is developed—is not necessarily a lot of expensive objects, as some people are apt to think. When a show fascinates it is because some fascinating theme, which may be an idea or a personality, has magnetized everything in the direction of a central attraction. One of the most imaginative and influential exhibitions in this country was the Hudson-Fulton show at the Metropolitan Museum in 1909, which reviewed North America from Henry Hudson's exploration of the river in 1609 to Robert Fulton's steam navigation on it in about 1809. To illustrate these two centuries of history, R. T. Haines Halsey and Luke Vincent Lockwood put together the first big exhibition of American decorative arts—furniture, panelling, glass, silver, etc.—in an exhibition whose novelty stimulated an interest that ultimately resulted in the formation of the American Wing, the Winterthur Museum and even the rebuilding of Colonial Williamsburg. To this day, the terminal date in the early 1800's more or less marks the latter-day limit for American furniture and silver that is seriously collectable. (One might add that our decorative arts begin to be more distinctively American only after Jefferson's embargo of 1806 forced us to design independently of England.) We may think that the Hudson-Fulton exhibition drew crowds because some of the objects, such as highboys by Savery, have since been canonized as a result of the

How to Bake an Exhibition 135

show, and so cost their thousands, but in those enviable days, the best old American furniture cost hardly more than new. The rare and essential ingredient of this epoch-making Hudson-Fulton exhibition was its imaginative conception.

Every year brings its crop of anniversaries to be commemorated by shows that usually group themselves around a personality. In 1964 we will celebrate the births of Shakespeare and Toulouse-Lautrec. It will be hard, if not impossible, to find an unexplored aspect of Lautrec, the way the Museum of Modern Art did for Rodin by emphasizing his anatomical virtuosity. Of course, the Lautrec shows may draw all the more people just because there will be no fresh revelations. Exhibitions of unknowns, which pique the elite, usually keep the rank and file at home by thousands. In the case of Shakespeare, we expect novelty in an author whose plays reveal something new at each reading and each production. Yet another re-appraisal should emerge out of the coming show of Shakespeareana from the collection at Stratford, Connecticut.

A clear idea of the theme of a show makes it easy to select what will contribute to it from what will not. But it is important never to forget the theme, never to be carried away by a liking for something that has nothing to do with the case. Since an exhibition is more than the sum of its parts, it is possible to make a fascinating one out of commonplace objects. The museum at Doylestown, Pennsylvania, assembles thousands of instruments and tools for all kinds of work, from a cobbler's bench to a gallows, which no one would cross the street to look at singly in the window of a second-hand store, but which, in groups and sequences, involve one like a nightmare.

If the theme of a show is an idea rather than a personality, it usually needs the help of some words to make it clear. The show can be explained in the foreword to a catalogue, but most visitors will get more out of very brief notes, in the style of telegrams, scattered here and there like a paper chase.

In such diminutive essays every word must act like a fishhook to catch the visitor as he drifts along. One hook ill baited,

A. HYATT MAYOR

or a paragraph that looks long, and the visitor is on his way else-where. The writer must imagine his reader as an intelligent person whose frame of reference can be counted on to include the upper average of knowledge, but who may sometimes turn out to know more than the writer. This means that the captions must never talk down, must present new or heterodox ideas unpretentiously, and that each caption should tease the reader by taking a different tone, or opening on a fresh note.

It goes without saying—but how often it needs to be said—that all labels must be in a legible, big type at a comfortable height and distance from the eye. Years ago the Museum of Modern Art began to enlarge type in photographic negatives that shot white letters at you off a black ground in a style that has happily spread.

Having selected and labeled your objects, *how do you arrange them in a gallery?* There are probably as many ways of doing this as there are people doing it, but I always begin by setting aside whatever arrests attention by its size or its vigor. These outstanding things must hold the centers of floors or walls, or the vanishing point of vistas, where they will attract compatible groups of things around them. Each group holds together through some affinity which can be a resemblance of design, or an intellectual interaction of ideas. Whoever assembles a show naturally knows the affinities of ideas, but he may find it harder to grasp the affinities of shapes and patterns because they are so obvious. So to hang a show effectively, one should begin by standing all the pictures in a row against the wall *upside down.* Gone is the girl's smile, the old man's penetrating glance, even the obnoxious kitten, and nothing remains but the bones of structure or the pattern of colors. Suddenly groups sort themselves out by similarities of pattern, and you see that you have several pictures that resemble lace, Chinese writing, clouds, beams, or fireworks. When you group these pictures right side up again, the similarities have intensified the impact of each picture in the group. And if you then hang each group tightly clumped together, throwing away a generous gap between

groups, you will accommodate many pictures without seeming to crowd them. The wall will fire at the passerby in salvos, or twenty-one-gun salutes.

The organization within groups is not always easy. The *Photography in the Fine Arts IV* show at the Metropolitan Museum was hung by using a practical method of fixing each picture onto the wall by resting it on a light portable frame, thus lining up all the bottom edges at one level that brought the middle of the picture more or less to the average eye height. This straight alignment settles the wall with a repeated design, but it is an order as mechanical as the rhymed couplets of the *Rape of the Lock*. If there is time to experiment, one gets more variety and stimulus out of intuitive and asymmetrical groupings, like those that Arthur Drexler assembled in the show of *The Photographer and the American Landscape* at the Museum of Modern Art. Each group amused with a change of pattern, setting off a photograph of clouds by skying it, or a downward view by dropping it almost to the floor. Thus the average eye did not meet the middle of each picture, but rather the horizon line of the perspective. This is worth remembering when hanging any kind of a picture with a distinct vanishing point in its perspective.

Drexler hung each group in an alcove painted a different pale tint to suggest sand, mist or sky, and each group was unified by being framed alike in pale wood, matte silver, gray or white. The whole show pulled together because John Szarkowski selected such magnificent expressions of America's consistently romantic approach to nature.

In the Metropolitan Museum's *Photography in the Fine Arts* show, Stuart Silver of the Museum's staff cleverly painted only the vista of door frames in a deep, rich harmony of blue, red and olive that contrasted with the pale gray of the long walls. The color photographs were hung on the gray walls, and black-and-white ones on the colored walls. New works of art can stand being surrounded by fresh colors that would make old works of art look dirty. But since a gallery is just a background for works

138 A. HYATT MAYOR

of art, its color and texture must keep it in the background, and it is well painted if the average visitor cannot recollect how it was painted.

These niceties of selection, labeling and hanging may seem persnickety, and indeed they often loom too large for many of us who work in museums, but they unconsciously affect even the most casual gallery goer. Such considerations are like the hand-sewing that unobtrusively distinguishes a made-to-order suit from one grabbed off the rack, or the grating of green ginger and other subtleties that make Chinese cooking exquisite.

The Old Man Mad About Painting

Introduction to *Hokusai*,
engagement calendar for 1967.

New York: The Metropolitan Museum of Art, [1966]

Katsushika Hokusai. Woodcuts in the *Manga* (*Sketches*), 1819.
Rogers Fund, 1931 (31.81.10).

F
EW ARTISTS would bear looking at every day for a year; their work does not have the variety and personality. It is not enough merely to be great, for the great painter may impound us unendurably in the singleness of his obsession. To be continuously interesting through a year's worth of fifty-two pictures, an artist must have eyes that gluttonize in every direction and an absolute command of hand. Such a one was Hokusai.

Hokusai was born in 1760 in what is now Tokyo. All his life he was as poor as his father, who polished mirrors for a subsistence. When he was a small boy drawing pictures, the Japanese began to print woodcuts in several colors. In his early teens, Hokusai was cutting wood blocks for publishers, and at eighteen he started to draw for other cutters in the studio of Shunsho. He adopted part of his master's name, calling himself Shunro, to show how completely he succumbed to Shunsho's rather weary style in prints of sulky, silken courtesans and the actors who impersonated them. If Hokusai had died before he was forty, while still lingering in this listless elegance, he would have been forgotten. He developed late in his eighty-nine years of life by dint of making over ten thousand woodcuts and some thirty to forty thousand drawings. Thus he was not altogether assuming humility when he said, at the age of seventy-five: "I have drawn things since I was six. All that I made before the age of sixty-five is not worth counting. At seventy-three I began to understand the true construction of animals, plants, trees, birds, fishes and insects. (He omits men.) At ninety I will enter into the secret of things. At a hundred and ten, everything— every dot, every dash—will live."

Hokusai died four years before Commodore Perry introduced foreigners into Japanese life. For over two centuries a few Dutch

The Old Man Mad About Painting 143

merchants had been tolerated on a three-hundred-yard rectangle of earth dumped into Nagasaki harbor for the confinement of outsiders. Hokusai, observing everything, once shows a "high nose" peering out of a window beyond a board wall, and being peered at from the street. Even though the Dutch were forbidden to cross the narrow bridge to the mainland, their clothes, their guns, their magnifying glasses, and their books did. Hokusai, living just when Japanese ideas were beginning to rub against ideas from Europe, can no longer quite believe in the fairy tale esthetics of the Lady Murasaki a thousand years before. Even the old ways of representing the world are going, for in one of his prints a Japanese street converges to a vanishing point, with figures diminishing in the distance, just like a plate in any western perspective book. His studies of fat people and thin people could well be Dürer's anatomical comparisons set to capering.

Whenever and wherever old ideas begin to be questioned, the unsettling generates energy. The breakup of ancient Japanese ideas supplies the motor that convulses Hokusai's wrestlers, fishermen, and jugglers. The pace of change drives him to explore every doing and happening of Japanese daily life as he saw it in his studio—the street. He is the only Japanese printmaker who threw himself into the turmoil of the slums rather than the high-flown sham of the stage.

Hokusai traveled fast because he traveled light, carrying little more than his brushes and his paper, changing his abode ninety-three times, and as restlessly adopting over thirty different names. As he flew, he absorbed every style that he saw, keeping consistently only the Japanese convention that ignores shadows. Shadows would have obstructed the racing of his line as it describes things with disembodied subtlety.

Japanese and Chinese artists are able to fling out lines writhing like strings in the wind because they do not move their brushes with the little muscle of their fingers, as we might do, but with the large muscles of their arm and shoulder. Nothing touches the paper but the brush tip that goes and goes, driven

A. HYATT MAYOR

by the dread of a pause that might drop a blot. Such a way of drawing puts its effort in outline and summarizes inner detail. The Japanese and Chinese see no interior logic of bone and muscle in their shadowless figures, and they escape our Greek abstract ideal of the body—never realized in nature—to concentrate their convention on the painted face of the geisha and the actor.

In Japanese prints the clean lines bound the transparent colors without crossing and obscuring them—sky tints that stain through the tough diaphanous tissue of the mulberry paper. These air colors capture the out-of-doors for a people who live more at the mercy of nature than we do, the rain stinging their cheeks through the splits in their straw rain clothes, the chill in their paper houses disjointing their fingers. In Hokusai's prints, the wind-squalls scatter hats and bully people, the snow blinds with awesome cold. We are far from the mild valleys of classic Chinese painting, where a philosopher pauses to contemplate the October mist on the cliffs, and time runs visibly in the rivers. Hokusai lived in the knockabout struggle of today. Like Daumier, he seemed a graphic buffoon to his contemporaries, but has grown with the years to a stature of command.

A Truth or Two
About Art History

First given as an address following the Museum Advisory
Council annual dinner, Princeton University, May 13, 1977.

Record of The Art Museum, Princeton University 36, 1 (1977):
22–24. Reprinted with revisions, in *Princeton Alumni
Collections, Works on Paper*, The Art Museum, Princeton
University, 1981: 23–26

"Prodigies." Woodcuts in Hartmann Schedel's so-called *Nuremberg Chronicle*. Nuremberg (Koberger), 1493.

Rogers Fund, 1906 (21.36.145).

I HAVE BEEN ASKED to speak to you, as graduates and undergraduates in the Department of Art and Archaeology, about the careers that are open to you and the Princeton resources that you can use to prepare yourselves. It is frightening how little we are captains of our fate. Like fish in a waterfall, we can nudge a little to the right and a little to the left, but we must rush with the speed of the stream. All you can do is to prepare yourselves as best you can for the stroke of luck that hopefully may happen. You must aim for a career in the kind of art that kindles your love, for love is the motor. This is a stuffy way of saying that you do well what you enjoy as a game—not a slugging match to knock out an opponent, but a game played for the zest of playing. If no works of art stir your admiration or your curiosity, then quit and join the lockstep of the civil service. Art history has enough hypocrites. But if certain kinds of art make the top of your head go cold, then aim for a career among the things that move you. If you are drawn to painting and sculpture, you can teach, write, buy and sell, or curate with equal success. If architecture fascinates you, you have no place in a museum or a dealer's gallery, but you must write or teach. If you want to handle the applied arts, you have to be in a museum where you can feel the glaze of a pot, weigh a Georgian spoon in your hand, examine the unfaded colors on the back of a tapestry.

If you enjoy tracing the whole development of some course of art through all the works that survive, then you will be happiest in a university where you can play solitaire with photographs, as the iconographers do. If you are aiming for a teaching position, you will probably give a talk at the Frick at one of their spring slave auctions. If you do, *don't* read a paper and send your audience to sleep with *mmmmm*. A talk is not a dissertation read aloud. It is a performance. Write out the dates and

names as a promptbook, and rely on the slides to give you the structure. Practice your talk in a room alone, standing on your feet. When you finally face your audience, calm your nerves by asking yourself how well you are using the mechanisms of acting. Is the column of air robust enough to launch the vowels smack at the back wall? Do the consonants clip the flow of vowels into intelligibility? Is it time for a pause? . . . Or should I speak a few unnecessary words so quickly that they strain understanding? Am I mumbling in an interminable monotone? Can I wake the sleepers by pointing out something on the screen in order to cross the stage and send my voice from a fresh direction? Such considerations are the basis for the minimal courtesy that every teacher owes to his class. But guard against the occupational disease that afflicts many teachers after years of filling fifty minutes with talk to audiences that do not have the experience to answer back, and that anyhow would not risk an action so impolitic. When you reach your forties, ask yourselves if you have forgotten to listen. *Odium scholasticum* drinks venom from the obsession of almost every professor to lecture at all the others. But all the world loves a listener.

You might think of teaching in another dimension through journalism if you write easily and react vividly to the visual. Journalism also has the advantage for women of putting them on an absolutely equal footing with men. You could have an even more active life through the gamble of dealing in works of art, with the excitement of verifying your hunches with the most tangible immediacy. The time has almost passed when an art dealer found it prudent to put his private clients at ease by being—or pretending to be—middling dumb. The important purchasers are now mostly museums through curators, who prefer a dealer with a matching academic background.

I have saved the museum world for the last because I know it best. The museum offers two roads to prominence, through writing and through administration. If you choose administration, you should go through a good business school, now that dwindling revenues have to be managed with ever greater skill,

and fresh funds have to be solicited. You will succeed if fund raising makes your heart beat like hunting big game, if you thrill at bringing down a donor with the first shot. And the doctor will probably like it, too. Now that America has its first white-collar proletariat, you cannot afford to be choosy in your way of getting your foot in the door. Go in as a clerk or an accountant if you want to be an administrator; as a secretary or a guard if you want to be a curator. If you can afford it, go in as a volunteer and make yourself indispensable. Your entry shows pluck, and once in, you can find ways to show your abilities, getting yourself transferred to something nearer your desires.

You may be able to choose between a big and a small museum. Life is more varied in a small museum, where you might spend the morning arranging a vitrine, lunch with a possible donor, and then pass the afternoon with town councilmen to get the sidewalk repaired. You might not learn very much about works of art, but you would learn a great deal about people. You would above all learn to be nice to absolutely everybody, for the little old lady with the run-down heels may be able to build you a new wing. A big museum invites learning without end, though in ways that may shock you after the spoon feeding of seminars. This became clear several years ago when foundations financed graduate students to work for a spell in museums. In their reports afterwards, the museum curators wrote that the students brought springtime, the dawn, the hope of a bright new age. But the student fellows wailed that they had had to install Eastlake chairs, had to check all the objects in an exhibition against the finding list, had to accession a feather boa. It was degrading! Worse, it was a bore! But bore or not, such chores provide the only way to learn a collection. And unless you know the collection thoroughly, you will not know where there are gaps to be filled, what offerings would be redundant, what kinds of exhibitions you could assemble from what you have, and how much you would need to borrow. In short, you become as useful as your memory. When you have learned one particular collection it is not easy to shift to another

collection, so that a curator cannot move about as readily as a teacher. In time you become a barnacle on the whale's belly, going where the whale goes. This is not as restricting as it used to be, for museums nowadays give more time for study and money for travel. Indeed, the whole museum career is changing as scarcity and high prices have ended the grand adventure of sweepstake ingurgitation. The task now is to sort out the accumulated heap, to investigate it piece by piece, and to publish catalogues. The Frick Collection and the Metropolitan Museum have led the way there; other museums will follow.

How can you use Princeton to prepare yourselves for such careers? You cannot get to the top unless you read French, Italian, and German, to which you must add Greek and Latin if you go in for archaeology. Don't learn trade words like *nuance*, *chiaroscuro*, *metope*, for they are alike in most modern languages. Concentrate on those beastly little connective words that differ in almost every language—words like *above, below, afterwards, in spite of, nevertheless*, for these are words that you will meet whether you read Kant or Peanuts. Read all the great poems, plays, and novels that you can, for Dante will lead you into the dramatic economy of Giotto, Racine will help you feel the balanced organization of Poussin, Flaubert will show you how the Impressionists looked at life. The more you know the more you see. Read general history, the history of science, of economics, of ideas, for these, like the history of art, are all peek holes into the central mystery of man. Any one approach, if pursued without reference to others, dwindles into something like nineteenth-century theology—a complex disputation about nothing in particular. And as you go about, look at absolutely everything comparatively. If you are to give your life to Greek and Roman sculpture, you will not see it profoundly unless you have looked hard at sculpture in China and Africa, at Donatello and Michelangelo, at Houdon and Rodin, even at the late works of David Smith. In the Princeton museum you can learn to look. If you want to get inside some painting, get a photograph and study it upside down until you understand how it is

A. HYATT MAYOR

organized. Then plant yourself in front of the original and start looking. You can keep your eye exploring if you draw it, no matter how awkwardly, or if you describe it detail by detail on a pad of paper. After about half an hour, a fog will lift, like breath leaving a windowpane, and you will enter. You will never forget the thrill. Learn to analyze a building from various points of view: the function as it governs the plan, the statics of stone or timber, the problem of shedding rainwater, the results of the abundance or scarcity of wood for scaffolding, the function of decoration, the ways in which muscle power could be gathered for lifting, and so on and on.

You are in the years when you can compare, adventure, feed your wonder and your admiration. So full a liberty will not come again until you retire at sixty-five or seventy. Throw yourself into it while you can, getting the widest possible experience to support a later specialty. Art history is not an exact science . . . like mathematics, that fresh young minds capture by assault. It is a way of life like farming, for which you need instruction but in which you prove yourself in the long haul. It is an intuitive understanding into which you can go plunging for a lifetime without fathoming bottom. It has borne some of its best fruits from the cross-fertilization of disciplines. Some of its most brilliant practitioners, including all the founding fathers, educated themselves into it from other professions. Since nothing should stop you from exploring and comparing, any dissertation that holds you down to a tiny point for more than two weeks does positive harm by slanting you toward a side issue for the rest of your life. When a major dissertation must be on a subject that has not been treated before, you are usually reduced to a detail that no one in his right mind would touch voluntarily. Yet if you have the luck to draw a subject with possibilities, you do not, at this stage, have the experience to discover the full treasure of its implications. Academic decorum forbids you to write plain English, for you must demonstrate professionalism by parading the shopworn trade slang that so often masks fuzzy seeing. As an antidote to the

obligatory jargon of your writing and the often turgid fudging of much of your required reading, read the Bible. The Bible, because plain, will make your writing forceful, give it nerve and dagger. It is largely because we no longer go to church to hear the Bible read aloud that our language has become trivial. Its content makes the Bible the supreme book for any lover of Western art. It is worth more than Vasari times Panofsky.

The Ph.D. is the union card for teaching, and may be becoming so, alas, for curating. It is a lazier yardstick than performance. But it should not have to be granted for a dissertation, since some of the very greatest minds in art history have been Socratics who never wrote. There is no reason why the highest degrees should not be granted like law degrees in the seventeenth century, on the basis of an all-embracing oral examination in a public hall. Candidates might promise their dissertations when they reach sixty-five and can write something useful. But I suppose that professors who have gotten to where they are through writing dissertations will naturally demand that their successors eat the same crow, the way children who have been beaten by their parents then grow up to be parents who beat their children.

Here endeth the first lesson.

An Interview with A. Hyatt Mayor

Conducted by Paul Cummings in 1968.

Archives of American Art Journal 18, 4 (1978): 2–19

PC What is the initial "A" for?

AHM Alpheus. My grandfather was Alpheus Hyatt, my uncle was Alpheus Hyatt, my great-grandfather was Alpheus Hyatt. His father was one of a number of sons in Baltimore, and my grandmother used to say that they were called Shadrach, Meshach, and Abednego who all died and Alpheus came along and he survived. But I don't use it. I always thought that it was a classical name, the Alpheus of Eurydice. But when I went to Mount Athos, the monks would ask me my name. It was no use saying Hyatt or Mayor, so I would say Alpheus. And they would say "very apostolic." Sure enough, there are two Alpheuses in the New Testament: the brother of Zebedee and somebody else. My great-great-great-grandfather or something like that, Christian Mayer, came from Ulm as the Consul from Würtemberg in the 1780's. He settled in Baltimore and the family has been there ever since. My mother's mother came from Kinderhook in upstate New York. My great-grandfather Hyatt was the son of the sort of Park & Tilford's of Baltimore, the very rich grocers. He was sent to Harvard just before the Civil War. The only letter of introduction he had was to the leading wine merchant of Boston. And he appalled his family by becoming a paleontologist. They didn't expect *that*. They'd much rather see him come back a drunkard, I think. My grandfather Mayor also went North. He went to be educated at Stevens Tech where he later taught. He worked with Edison on the phonograph and the telephone.

PC Well, since everybody was from Baltimore, how did you come to be born in Annisquam?

AHM Because my grandfather Hyatt got his first job as curator of the Natural History collections in the Peabody Institute in Salem. Then he also founded the Teachers School of Science

in Boston. He looked for a country place, and found this dilapidated seventeenth-century house which belonged to a family that had been bankrupt so that the house had passed into the hands of the bank. And he bought that house. That's the only time that land has ever been sold since 1663, which is rather unusual. I was born in a room in that house where my grandfather established the marine biological laboratory, which then moved to Wood's Hole. And that started right in that little back room in our old house. We only lived there in the summer. In the winter we lived in all sorts of places. My father was a marine biologist who ran a Carnegie Laboratory on the last of the Florida keys, the Dry Tortugas.

PC Did that inspire any interest in nature in a scientific way?

AHM It should have. I suppose everybody so expected me to be a naturalist that I couldn't do it. In a sense, of course, I suppose that I have combined art and natural history in art history.

PC What kind of school could you go to then if you were traveling and living in these different places?

AHM I was always the new boy in a new school wherever I went, because we never lived more than a couple of winters in one place until I was of high school age when we settled in Princeton. We lived in Sharon, Massachusetts, which is where I first went to school. Then we went abroad and we lived in Mousehole near Penzance in Cornwall for a summer. This was when I was seven and eight. And then we lived in a place called Auvers-sur-Oise. And that's really rather amusing. My aunt, Anna Hyatt Huntington, is a sculptor. And she was doing a Joan of Arc statue in Paris. She wanted a summer studio which would be cheap and on the ground floor so you could wheel in heavy sculpture. So she and my mother took a train to the end of the line. Every time the train slowed down they looked out

and they would see, you know, those silvered globes in the gardens. They would see a factory roof. Finally the train slowed down to a little village where roses were growing over the garden walls and thatches. Beyond there were bachelor buttons and poppies in the field. It was just beautiful. So they got out. And they asked the *chef de gare* if he had any kind of barracks or shed that would serve as a studio. And he said, "Mesdames, nous n'avons que des ateliers." They had landed in Auvers-sur-Oise where Van Gogh shot himself, where Pissarro painted, where Cézanne painted. And they hired the studio of Daubigny, whose backyard had been painted by Van Gogh.

PC Well, you were how old? About seven or eight?

AHM I can remember very well because when I came home it was the spring of 1909 and the Lincoln pennies had just come out then. That fixes it in my mind as a little boy. We spent the winter before that in Naples in an apartment overlooking the bay, which is fascinating. Because when storms blew up the water in the bay would turn peacock green and the sunken villas and temples (because all that land is sunk) out by Pozzuoli, on the side away from Vesuvius, would be squares of chocolate brown in the dark peacock green. You could tell exactly where those buildings were. And that only happens when storms are brewing. My father at that time was on an expedition to Australia. He wanted to measure the growth of the Great Barrier Reef, the coral reef there, and he had to spend a while. And while he was absent on those long trips we were taken abroad to learn languages. That was first in 1908 and 1909 and again in 1912, 1913, and 1914.

PC That's marvelous. After Naples you went where?

AHM Then we came home and lived in Princeton for a while, for several years. And then we went off to Germany for two

winters and the summer between. That was into the summer of 1914. We came home because of the war. And then we settled in Princeton.

PC You went to Princeton because you were living there?

AHM Because we were living there. Because my father, although he was not a member of the faculty, had a lectureship there. He was really employed by the Carnegie Institution. But having a lectureship, we could go there free except for ten dollars a year in library fees. And also I saved money by living at home.

PC What was Princeton like as a school in those days?

AHM It was just like a continuation of high school really. There were some very, very good teachers there. There was a Frenchman called Louis Cons who looked like a truffle pig, always buttoned up in absurd overcoats and going around to rummage sales and coming home hugging ghastly lamps that he'd bought at a small price. A charming, wonderful man. He gave a course announced as being "Rabelais, Montaigne and the Pléiade." I never got so much out of anybody. He was an absolutely marvelous man. We started off I think with Rabelais. And, of course, we hardly got through him so we had to do it the next spring again for the Pléiade, which was very, very good indeed. He would ramble off in free association on all the kinds of subjects that would occur to a wonderfully stored historical mind: Latin grammar of the Middle Ages, the voyages of discovery, the travels of Isabella the Catholic, Rabelais' student days. He was a great, great teacher. And we didn't do one lick of work, but I never got so much out of anything that I ever did. Also of course to have the run of the stacks of the library. You'd go looking for a book and find four or five much more interesting on the way. That was wonderful. Books should have a difficult classification. They should be hard to find just so you might stumble on something better.

A. HYATT MAYOR

PC Well, what did you major in?

AHM I didn't realize I was majoring in anything. And when I had my cap and gown on that rainy day of the graduation, there was a program and I discovered that I was graduating with high honors in modern languages. Somebody had kindly added it all up and said I could rate that. I was not aware of having taken many language courses, I just simply took the things that interested me, but it happened to be a good many language courses. I took one or two courses in the history of art, one with Frank Jewett Mather, who was wonderful. And he gave a course in Italian painting, mostly the early painting. He was a magnetic, marvelous mind, not, I would say, a great scholar, not a graduate teacher, but an incredible man for attracting people in. He could lead the horse to water and make it thirsty, which is a rare gift. So I owe him a great deal. I think really I owe my interest in the history of art to him. He collected beautiful drawings and some rather good paintings, but in those days it never occurred to him to bring a drawing or a painting into the class and pass it around. One studied from photographs and slides. But he was a fascinating man, a little sort of rabbit-shaped, hairy man, very impulsive, warmhearted, charming. I loved him. And, of course, [he] descended from all the Mathers there are. Right by the front door in his house on Evelyn Place he kept an impression of that famous woodcut of Doctor Richard Mather, which is the first woodcut made in North America, which had been given to him by an aunt who kept it in her sewing box. He was so attached to this thing that he hung it always by the front door so that in case the house burned he could always rescue that.

PC Well, from Princeton you became a Rhodes scholar?

AHM Then I became a Rhodes scholar, yes. . . . In those days I thought that English literature was my dish and that I wanted to write. And Oxford seemed like a good place to prepare for that. I don't exactly know why I was hipped on being a Rhodes

scholar, but I was. I was sent to Christchurch, which was the largest college with the richest and the poorest and the greatest variety of people. I was given a tutor called Ridley, who had been brilliant in Greats and was therefore given a tutorship in English, about which he didn't give one hoot. I thought I'd just have to get rid of him. I moved heaven and earth and changed my degree to a B. Litt., which was rather hard to do, and was determined to do it with some non-Oxonian, either a Frenchman or a Spaniard. I went around one evening to the head of the French Department, who was a man called Rudler. He wasn't at home that night. Then I went a few streets away to Wellington Square to the head of the Spanish Department, Francisco de Arteaga, who was home. He opened the door himself. He was a little white-haired man with bright blue eyes and all the warmth and impetuosity of a Madrileño. A marvelous man, who had married an Englishwoman much younger than he. He used to write couplets while he was shaving, you know, little verses, which he wrote and never read—just filed away in a drawer. Oh, he was absolutely great. A great scholar, and wonderful fun.

PC You liked Oxford then more than Princeton?

AHM Yes. Oh, yes. Well, Oxford, after all, was an experience and Princeton was just a day school. The experience of just sitting down and talking about any darn thing, with no holds barred, was really absolutely intoxicating. I'm sure that if I had lived on the campus in Princeton I would have had that experience then. But coming to me later in life when I was twenty-two, it meant more. It was more of a revelation. You know, youth *is* wasted on the young. If you can have some of the experiences a bit later it's so much the better. I did a thesis degree, which left me entirely free. Therefore I could read all kinds of things. And did. I read all sorts of things and got my silly old thesis finished, and passed, and satisfied the requirements of the people who sent me so they wouldn't feel I had let them down.

A. HYATT MAYOR

PC What did you write on?

AHM I wrote on the influence of Quixote on English litera-
ture. A stupid subject. Happily a German had written a Ph.D.
thesis on exactly that subject. And my examiners, who could
not read German, didn't realize that most of what I had was re-
arranged from this German with a few little additions I was
able to find on my own. And it was a miserable performance. I
was examined by Arteaga and Henry Thomas, who used to be
head of the Spanish Department of the British Museum. When
I came in Mr. Thomas asked me if I was going to publish this
thesis. I said, "Certainly not." And you could just see the sigh
of relief that he gave.

PC How many languages did you know by this time?

AHM Well, of course I had learned French really well at
Auvers. And then I learned Spanish quite well at Princeton
from an excellent teacher called Marden. Then, let me see, when
I taught at Vassar I picked up Italian from a wonderful girl
there called Gabriella Bosano. She let me sit in the back of the
class with all the girls and I could listen in and that gave me a
start on Italian. The French helped all those things, of course.
And, of course, living in Germany for two winters I got German
quite thoroughly. Languages are useful, not so much to com-
municate as to read, because then you have information ac-
cessible. I've found it absolutely invaluable to be able to read
rapidly, to skip through a page of French or Italian or Spanish,
and then to know where you've got to read slowly and concen-
trate. I must say that German is a language that I still can't read
with my heels higher than my head.

PC Well, did you have intentions of teaching after you finished
school?

AHM Well, I did teach, actually. I taught at Vassar. History

of art, about which I knew absolutely nothing. Just after Princeton. You know those old days were so informal. One never could do those things nowadays. The head of the art department at Vassar was Oliver Tonks, who was an Englishman. He didn't want to be bothered, thank you. He was the ideal boss. I could go ahead and do exactly as I pleased. Provided I didn't make any trouble for him, it was all right. . . . Then, when I left to get my Rhodes scholarship, I was succeeded by Alfred Barr. Then came Jerry Abbott and Russell Hitchcock. It was a very good system to take on young men for their first jobs for a year or two and then send them on their way. That's what the Frick does with their lecturers nowadays. I'm very happy to say that I was the head of the procession.

PC Let's see. Well, you started at the Metropolitan then.

AHM I got engaged in the late summer of 1931. My wife's family rented a house in Annisquam just after her father died in 1929. Her father was a nose and throat specialist in St. Louis, had helped found the medical school there, and was very prominent in the Barnes Hospital. In fact, he was *the* great nose and throat specialist in the United States. All the opera singers and people like that used to come to him. When I wanted to get married, of course, it was in the draggy depths of the Depression. So I hawked myself around to all the people I knew in the universities on the Eastern seaboard. They would have none of me. And finally, completely by accident, I just stumbled in to the Print Department of the Metropolitan Museum. Ivins had the courage to hire me. And, believe me, it took courage, because I had no qualifications whatsoever beyond being able to read languages. But that was his reason; that I could inform myself, that I could teach myself.

PC So what were you hired to do at the Metropolitan?

AHM I was hired to learn the Print Department business.

A. HYATT MAYOR

And I was hired because I had not gone to the Fogg and was, therefore, not warped, tainted, smeared, or whatever. Ivins was anti-Fogg, although he was a great friend of Paul J. Sachs. In a sense he was right. Because the Fogg in those days did not turn out museum curators; it turned out directors. And probably rightly. Back in the twenties, museums were springing up all over the country and what they needed were bright personable young men who could persuade people to give money, keep the old ladies happy, and get things going. And they didn't have to know much. But they had to know something of the world of dealers and a smattering of works of art. But that was not what Ivins wanted for his assistant. I was simply turned loose with no instructions except that I was to learn the Collection. And the Collection then was several thousand boxes of prints. I would take the various catalogues and the books and I would open the boxes and try to remember what was in them. And then I had to man the study room, which is where the public comes in and asks questions and you get stuff out for them. It's the maid service for the Collection. Which teaches you an enormous amount, because just about every other question knocks you off your perch and you have to go and look it up. And if you know where to look it up you are doing very well. I've always felt that I wasn't held to know things but to know where to find out things. Specialists have never bothered me or intimidated me because I feel that everybody is a specialist. I know the contents of my pants' pockets better than anybody else does. I'm a specialist on that. And of course there's an enormous amount of stock taking and inventory making. All the things that come in have to be given their numbers and described and cards made for them and all that kind of thing. I did a great deal of that, which is the way you learn the collection. The first job that I set for myself outside that was to make an index to the plates of Diderot's *Encyclopédie*. Which was eleven volumes, about 3,000 engravings of all the arts and techniques and sciences of the 1760's and 1770's. And that was a fascinating thing to do. I've never regretted that.

PC I'm quite curious about how William Ivins worked and what kind of personality he was.

AHM Well, he was a very tall, slatternly kind of man, he didn't quite shamble like the halves of two camels the way Steichen does, but he walked a little like that. And he looked like a sort of Goethe, rather consciously sloppy. He had the Harvard hat, all in holes and tatters; but that wasn't because it was an old hat; it was the style; it was quite deliberate. He was more an owl than a lark and he'd work late at night as lawyers do and would come into the Museum at eleven o'clock in the morning. As a lawyer, he had an intemperate way of arguing, and it was always the *argumentum ad hominum*. He had a terrible, absolutely an ungovernable temper. You could understand all that, but it didn't make it any easier. If I hadn't had school bills and pediatricians and diapers to pay for, I would not have lasted out, and it would have been a great mistake to have left. There's no question about that. But, somehow, having to pay for a family gives one a stomach for crow.

PC I'm curious about the early collection or groups of prints that came into the department. First there was the Harris B. Dick Collection. Were there other ones like that?

AHM One of the most remarkable gifts came from Felix Warburg, who lived where the Jewish Museum is now. In the billiard room there (it was the corner room on the ground floor) on the billiard table they kept the large portfolios of books of prints. Gerald Warburg told me that he and his brothers were always annoyed by this collection because whenever they wanted to shoot pool they had to take off these great big heavy volumes. When he died, he bequeathed his collection to Mrs. Warburg for her lifetime, and, at her death, the children were to take what they wanted out of it, and the remainder was to come to the Metropolitan. Well, the family got together and said they didn't want that at all; they would like the Metropolitan to choose immediately (this was 1941) what it either

A. HYATT MAYOR

lacked altogether, or had in worse impressions. In other words, we were not to take duplicates. Ivins and I worked very hard on this and very scrupulously observed these requirements. And in came some of the most wonderful Rembrandts you *ever*, *ever* saw, things you'd never, never get nowadays or again. It was one of the very, very great gifts. . . . I think perhaps the biggest purchased lot that ever came in was what I got out of the collection of Prince Lichtenstein, who lived in Vaduz—and had a collection which, I suppose, goes back to the early fifteen hundreds, or something like that, when the Emperor Maximilian would give his woodcut portraits to his various friends. It had been greatly augmented in the 18th century, all laid down on 18th-century cardboard, which was very carefully sized and calendared on the back of each sheet so that the sheets wouldn't be rough against the prints facing them. These things were put away in large red morocco portfolios with green linen flaps to keep the dust out. About 350 portfolios. What I got was all the unsaleable things. I got the reproductive prints of the Italian schools, of the German schools. It was a great purchase because they are not collector's prints. They are not prints you would ever show on the walls. They're not works of art, but they're the prints that answer questions. And there's no collection like them outside the very old collections like Paris or Vienna, the collections that were the pre-photographic approach to works of art, when you got engravings of things for lack of any better picture.

PC How did you become associated with things like the Brookgreen Gardens and all these various institutes of which you're a trustee?

AHM Those things just fall on you, I have no idea how, but they just do. They come to everybody. That's a matter of time. But my connections with Brookgreen Gardens and the Hispanic Society were entirely through my uncle Archer Huntington. Did I talk about him?

PC No, we haven't talked about him or about your aunt either.

AHM Well, Aunt Anna did a medal back around 1920, I suppose, of William Dean Howells for the Academy of Arts and Letters. This was commissioned by Archer Huntington. At that time his first wife had left him and he was terribly gloomy. He really didn't care if he lived or died. And Aunt Anna somehow saw this. I don't know how she saw it, but somehow he saw that she saw. And this made a bond between two people who really were very unlikely ever to have become associated. . . . They were finally married in her studio standing by the piano. I was there. He was terribly nice to me and I was very, very fond of him. He was an extraordinary man. He came of that generation which could dine out if they talked well; and he talked divinely. I have never heard anybody with that instant lapidary wit. He was at ease in any language, French, Spanish (the only non-Spaniard I've ever met who spoke Spanish eloquently—not only correctly—but eloquently). He could recite scraps of the *Koran* in Arabic. He was an astonishing man.

PC He did a very good translation of *The Cid*, didn't he?

AHM Yes, it still is the classic translation. And his notes are still the classic notes on *The Cid*. He never went to college, which, curiously enough, bothered him. He knew far more than almost any college graduate I've ever met. . . . He was brought up more or less traveling around Europe with his mother. So, in this solitary life with his mother, going around to various grand hotels, his toys were shoe boxes in which he arranged miniature works of art and made museums, because museums were what she went to all the time. So those were his toys. Very naturally, when he grew up museums were the things that continued to interest him. And he founded, I think, thirteen in all. He got very much interested in Spanish things. Apparently that was because when he was, I think, eighteen, his father was invited down to Mexico to do something about the Mexican rail-

168 A. HYATT MAYOR

roads, invited by Porfirio Diaz. The father took Uncle Archer along on the trip. His father, Collis Huntington, put through the trans-continental railroad. They arrived by train in Mexico City in the morning. That evening they had to attend a very grand banquet in the Chapultepec Palace. So they arrived there at a rather late hour as one does to dine in a Spanish land. All the grandees of Mexico were there, everybody dressed up to the nines. Each gentleman was supposed to take a lady on his arm and drift into the banquet hall. At that very moment poor Uncle Archer passed out cold. The altitude had got him. And of course he was embarrassed. You can imagine an eighteen-year-old at his first grand, grown-up party having that happen. Well, the Mexicans all gathered around him and they were so nice that I think he fell in love with the Spanish frame of mind at that moment and devoted the rest of his life to it. Very shortly after that he learned Spanish and Arabic, because Arabic is so much a part of Spanish, and went all over Spain on an unfortunate donkey.

PC Well, what about the Hispanic Society? You've been involved with that for a long while.

AHM Oh, yes, certainly. I really am involved with that. One time when I was in the Metropolitan my uncle telephoned me and said, "Can you come up here so quickly that the air closes behind you with a snap?" He had a way of speaking, a lovely, old-fashioned way. And he then took me into the library, locked the door, sat me down very solemnly, and said, "Would you be a trustee of the Hispanic Society? But you must promise me never, never, never to change one single thing." Well, you know, he was eighty years old and I said, "Certainly." He ran everything. Every single decision was his. He didn't want an active Board at all. No discussion. At any rate, when he died there was absolutely nobody to take over. There was no director. There was no procedure for running the place. It was a private museum. And there were a lot of ladies who were very bright

and who knew their specialties marvelously; there was no question about that. And many of them wrote very well, but had no idea of what went on outside the walls they worked in all the time. He had ruled them very strictly, and he didn't tolerate any, *any* interference or any suggestions of any kind from anybody. My aunt said would I take over? Well, there was nothing else I could do. I went up there a couple of days a week in the beginning, or at least one day, and simply tried to hold their hands and tell them that things would go on and this was not the end and they must brace up and do something constructive. And that gradually got them writing again, interested in things. And I sort of made bridges to the outside world.

PC How did you become associated with the museums in Madrid and the other places in Spain?

AHM Uncle Archer had been a member of everything in Spain, absolutely everything, because he knew absolutely everybody. And that is no fooling. He was an intimate friend of all the great Spaniards of his age: the Duke of Alba, the King, everybody from there on down, all the museum people, all the writers, everybody. He really was part of the intellectual life of Madrid. So that, as his nephew by marriage and his successor at the Hispanic, they thought they ought to do something for him. And they therefore gave me these various *entrées* to academies. It was rather terrifying, I must say. I finally got up my courage to go to Madrid. I asked a young Spaniard, "How does one behave in Spanish society?" And he said, "Think that you're at Court in Vienna in 1860 and you'll be all right." And he was perfectly correct.

PC Do you think [having an aunt who was a sculptor] was a great influence in your decisions about things to acquire for the Museum or exhibition ideas?

AHM Oh, yes, certainly. It gave me, of course, an interest not

A. HYATT MAYOR

only in flat art but in art in the round. I think a sculptural sense is somehow rarer than a sense of drawing or painting. At least fewer people have it. And that was happily just built into my childhood. Which is so lucky. And I'm sure that without that experience as a small boy I would never have had such a wide interest in the Metropolitan Museum. I really have been sort of interested in more different departments than have any of my curatorial friends. They become highly specialized. And I'm happy to say that I was never specialized. One can't be in prints. Because they leak out into everything, into city planning, into the law, into dynastic history, into all the technologies. And it is anything but a specialty. All the other departments in the Metropolitan or in any museum are limited by a medium like painting, or a use like armor, or a period like Greek and Roman, or a culture like the Islamic things. Whereas prints are not limited by any of those things at all. And I always thought that my great virtue at the Metropolitan Museum was that I had a wide ignorance. That's the most important thing I contributed. And, although I never knew very much, exactly, I knew where to look it up.

PC Well, in the years you were there, the Museum must have changed enormously, through the Depression and then through the war.

AHM Oh, yes. When I was a boy you paid twenty-five cents to get in on wash days and fish days and that meant that you had the place absolutely to yourself. Francis Taylor abolished the pay days. They brought in at that time about $18,000 a year which was, of course, nothing in our budget. And they kept away a great many people, especially during the Depression. I think he was wise to make it free. Nowadays if one wants to see something in deserted galleries you just go before noon. . . . Any art collection should be tailored to the needs of the town it's in. New York, I suppose, is the most complex town there is today. It has more different kinds of things being done in it than any

other city. So that it needs a collection just about as complex as you can get it. It's hard to think of a work of art that would not be of interest to somebody in this town. Whereas Boston is entirely different. There's no theatre, there's no fashion industry, publishing is minor. So their print collection is a collection of the great artistic masterpieces, which is exactly what the town needs. Chicago is also a town of private collectors; no theatre, no fashion design. There is a good deal of architectural designing, but modern architectural design does not look to the past, so that has no bearing. Therefore, Chicago has collected the great masters as they were sorted out in, say, 1920 to 1950. And they have the greatest lot in the country of Odilon Redon, Toulouse-Lautrec, very remarkable early prints, and wonderful Picassos. It's a different kind of collection. I always thought it was more important here to get a lot of different things rather than some one very expensive thing. That seemed to be more important. Maybe I was wrong. I collected all kinds of things that were very definitely not. I made a great effort to collect the American commercial trade catalogues of all the things that might either enter the Museum some day or be of interest; that is to say, clothing, glassware, china, interior decoration of all kinds, furniture especially; so that I think we have probably the biggest lot anywhere, especially American catalogues, of all the decorative arts. I steered clear of, say, farm machinery, plumbing pipes. But when it was decorated toilet bowls, I got them and all the things that showed any kind of style and fashion. This collection had to be done very quietly because the various directors, especially Francis Taylor, thought I was misspending the Museum's money. So I never mentioned these things in annual reports, never showed them, didn't talk about them very much. But now it's one of the most used sections of the collection. Now these things are terribly expensive. Things we used to buy for three to five dollars cost twenty-five to seventy-five, when you can find them. But in those days they were worth just enough to make it worthwhile for a bookseller to stock them, but not so expensive as to strain my modest

A. HYATT MAYOR

resources. And I also collected as much as I could of foreign catalogues. The first great catalogues were issued in England beginning, say, in the 1760's, for brassware, silverware, and pottery. And we got all of those we could.

PC How did you get the idea to start collecting these things?

AHM I wanted the documents for the American Wing of the future. And the kind of furniture that's in the catalogues I collected is, of course, the kind of furniture that nobody would think could ever get into the American Wing. But when it gets rare enough and expensive enough, it will. We'll have an 1880 room someday. It'll all come in. And I wanted the collection to be in a position of strength when the American Wing needed that documentation. And the time for getting it was at the moment. I think the time has already passed when one could repeat that collection. These things, curiously enough, are frightfully rare. They're paperbound. They're thrown away. When they do survive, they're often in bad shape. There are two or three catalogues that turn up quite often because they must have survived in a huge trunk. But by and large they don't survive.

PC You became curator in 1946? Was this a great change for you, you know, taking over the department?

AHM Oh, yes, certainly that is always a great change. Naturally. It meant that I could run things my own way. I made very, very few changes from what Ivins had done. I tried not to make enemies and manufacture them. That was a certain change. I showed the prints in a somewhat different way. He had always framed prints in dark brown frames, which I thought was rather distracting. So I had all the frames bleached so they'd look as nearly as possible like the mats. And that more or less made the frames vanish. Lightened up in this way, you could put in more prints, while there seemed to be less. And I had large

slanting decks made which were thirty inches high, with great sheets of plexiglass on them, eight feet wide, and they slanted so they brought the things in about the position of a book that you'd hold in your hand. Then the prints were put in there without frames, with their mat and their simple label. You were supposed to forget the surroundings so you could just see the print and nothing else. And then for interest in my shows I tried to make explanatory labels which were typed up and put on the mats on one side, say, about every three or four mats, not every one, because that's too much reading. And it's rather a difficult thing to write those labels. They're not easy. You have to think of somebody intelligent, with a general education, who is also impatient, who's been standing too long on his feet and has to be kept very much interested if he's going to read a label. Each label, I thought, should take a different approach. You should never know when you began one whether it was going to be factual, flippant or serious, appreciative, or whatever. Each should strike a different note of some central theme. And I enjoyed very much indeed doing it. It's a lot of preparation. You have to really work for weeks on a show. I never wanted to show very many prints at one time. A hundred is about all you can see at one go. Somebody once said that you can really *see* works of art for half an hour, then the next half hour you check off the existence of things, after that you just wander about hoping for some indecency. There's a lot in that. . . . All my shows were idea shows, I would say. They were in a sense visual, but not aesthetic, if you could make a distinction. I hung things visually. And often, if I wanted to find out what pictures to put together, I would stand them all upside down and then somehow or other the cognate patterns would sort themselves out. One should always look at pictures upside down because then you no longer see the smile on the pretty girl or the gesture or anything like that. What you are left with is the quality of line, if it's a drawing, pure, because it's without significance. It's as though it were abstract. Then after you've studied the thing upside down you turn it around and study it on its feet, and it's

A. HYATT MAYOR

a new picture. You see quite different values that you hadn't seen before.

PC That's marvelous. Ivins was at the Museum until when?

AHM Until 1946. He didn't want to go at all, but he was sixty-five and it was an ironclad rule that one just went automatically. He knew this had to happen. So that about five years before he bought a small house in Woodbury, Connecticut. He was not at all a country man; he was a city man, bone and blood. But he forced himself to be interested in tree peonies. He wrote up to Professor Saunders at Clinton and bought tree peonies and planted them and tried to get himself interested. And of course they died on him—he really didn't care about them. It was very sad. Then he brought out all their furniture from town and put his money into very handsome French wallpapers. That was his one luxury. It was a pretty house. And Mrs. Ivins, who was an excellent artist, made it really charming. But he never should have moved. He should have stayed in the city. He was, as I think I've said before, entirely a lawyer. And he would work out problems exactly the way a lawyer would argue a case, that is, look up all the precedents. Once that case had been argued, as it were, he filed it in his mind along with all the other legal precedents. When that subject came up, out came the entire lawyer's argument. So that he was a fascinating man to listen to if you hadn't heard the lawyer's argument before. But these things did repeat themselves pretty much verbatim. And if you hung around him for a while you knew what to expect. He should not have changed his habits.

PC How many directors did you work with at the Metropolitan?

AHM I came in 1932. Robinson might have been dead a couple of years then. Herbert Winlock had recently taken over. Winlock was an Egyptologist. A terribly nice man. I was very fond

of him. He looked like sort of a battered granite bust of a Roman pro-consul, weathered and tanned and hardy. A lovely man. And wonderful when he talked with enormous nostalgia and romance about Egypt, about the nights there, about the *fellaheen* and their conversations, about discovering this and finding that. He was really a born Egyptologist. When he was a little boy he had mummified a mouse and made a set of coffins for it. There was no question of what he'd be, ever. Then when he failed, Ivins took over. It was a great pity that Ivins couldn't have got people's loyalty because he had excellent ideas, admirable ideas. Always rubbed them the wrong way. Unfortunately, when he argued with you and you began to yield and see his point of view, instead of then lying back and letting you come around on your own steam, he then redoubled his pressure. Just rode right over. And of course forced you to resist; you could not help resisting. He was psychologically about as inept as a man could be. Intellectually he was brilliant.

PC Do any of the exhibitions stand out as sort of favorite enterprises?

AHM Oh, yes. Perhaps the most interesting exhibition I worked on was *Life in America* for the World's Fair in 1939. Ivins at that time was the acting director. The Trustees thought that we ought to have some kind of very special show for all the visitors who came to the World's Fair. But they couldn't decide what it should be. Time ran on, ran on, and ran on. Finally, there was about three months until the opening date, which, of course, is no time at all to assemble any kind of a complicated show. And Ivins said, "All right, boys, we'll do something on *my* plan." And his idea then was to make an exhibition of all the American paintings that showed American life; genre pictures, the West, industrial life, all that kind of thing, everything that showed how people used to live in this country. That kind of painting in those days was in some museums, on the top floors of club houses, but never hung out on the front line. So Her-

A. HYATT MAYOR

mann Williams, who later became director of the Corcoran in Washington, and I went out on a trip. We were given carfare, a camera, which I managed, and we were just to bring back photographs and descriptions of everything we could find, whatever it might be. We could go where we pleased and we were given *carte blanche*. Of course, there was a committee in the Museum which would select what we recommended. It was just about the most wonderful trip I ever took. And Bill was a wonderful man to work with. We worked beautifully as a partnership. I brought back lots of photographs, and we assembled a show of, I suppose, two or three hundred paintings. And that catalogue had to be done in a hell of a hurry. So my wife and I (that's the only venture we've ever done together in this kind of thing) went down to the Public Library and just barricaded ourselves in books. We had a wonderful time. It was all done in such a hurry that it's a very fallible catalogue, but it still is interesting. Out of that catalogue came Marshall Davidson's big book on life in America. I gave Marshall all my photographs and all my notes. The show, of course, made an immense impression. It changed American collecting. And all this collecting that's done nowadays, the Hudson River School and things like that, is the outcome of that exhibition. We had wonderful things in that show, absolutely marvelous.

Bibliography

BOOKS

The Metropolitan Museum of Art: Sporting Prints and Paintings. New York: The Metropolitan Museum of Art, 1937.

The Bibiena Family. New York: H. Bittner and Company, 1945.

Giovanni Battista Piranesi. New York: H. Bittner and Company, 1952.

Prints & People: A Social History of Printed Pictures. New York: The Metropolitan Museum of Art, 1971 (distributed by New York Graphic Society; reprinted in paperback by Princeton University Press, 1980).

Popular Prints of the Americas. New York: Crown Books, 1973 (Italian edition, 1973, by Electa Editrice, Milan).

Goya: 67 Drawings. New York: The Metropolitan Museum of Art. 1974.

American Art at the Century, with Mark Davis. New York: The Century Association, 1977.

Rembrandt and the Bible. New York: The Metropolitan Museum of Art, 1979 (reprinted from *The Metropolitan Museum of Art Bulletin* n.s. 36, 3, Winter, 1978–79).

The Metropolitan Museum of Art: Favorite Paintings. New York: Crown Publishers, 1979.

ARTICLES IN PERIODICALS

"Gordon Craig's Ideas of Drama." *Hound & Horn* 2, 3 (April–June 1929): 236–49.

"Picasso's Method." *Hound & Horn* 3, 2 (January–March 1930): 176–88.

"The 'American Note'? " *Hound & Horn* 3, 3 (April–June 1930): 403–4.

"Towards Stronger Reasons for Deploring American Painting." *Hound & Horn* 3, 4 (July–September 1930): 568–69.

"Museums Modern and Metropolitan." *Hound & Horn* 4, 1 (October–December 1930): 111–12.

"New York Letter." *Formes* 11 (January 1931): 13–14.

"On the Imitation of Nature." *Hound & Horn* 4, 2 (January–March 1931): 265–67.

"'American Letter." *Formes* 12 (February 1931): 35–36.

"New York Letter." *Formes* 13 (March 1931): 51–52.

"American Letter." *Formes* 15 (May 1931): 86–87.

"Translation." *Hound & Horn* 5, 1 (October–December 1931): 5–17.

"All on the Shoulders of Two." *Hound & Horn* 5, 1 (October–December 1931): 91–93.

"In Hopes." *Hound & Horn* 5, 2 (January–March 1932): 288–91.

"Gaston Lachaise." *Hound & Horn* 5, 4 (July–September 1932): 563–64.

"In Reply to Mr. Damon." *Hound & Horn* 5, 4 (July–September 1932): 670–72.

"William Bouguereau." *Creative Art* 11 (September 1932): 50–54.

"Le Monument du Costume." *The Bulletin of The Metropolitan Museum of Art* 28, 5 (May 1933): 87–88.

"Three Hundred Years of Landscape." *The Bulletin of The Metropolitan Museum of Art* 28, 11 (November 1933): 193–95.

"Goya's Giant." *The Bulletin of The Metropolitan Museum of Art* 30, 8 (August 1935): 153–54.

"French Bookbindings." *The Bulletin of The Metropolitan Museum of Art* 31, 1 (January 1936): 8–9.

"Goya's 'Disasters of War.'" *American Magazine of Art* 29 (November 1936): 710–15.

"An Exhibition of Sporting Prints and Paintings." *The Bulletin of The Metropolitan Museum of Art* 32, 3 (March 1937): 51–54.

"A Gift of Prints." *The Bulletin of The Metropolitan Museum of Art* 32, 6 (June 1937): 140–43.

"Giulio Campagnola." *The Bulletin of The Metropolitan Museum of Art* 32, 8 (August 1937): 192–96.

"An Early Whistler Lithograph." *The Print Collector's Quarterly* 24 (October 1937): 305–7.

"Two Midwinter Print Shows." *Parnassus* 10, 2 (February 1938): 13–14.

"A Woodcut in the Style of Veronese." *The Bulletin of The Metropolitan Museum of Art* 33, 5 (May 1938): 128–30.

"Piranesi." *The Bulletin of The Metropolitan Museum of Art* 33, 12 (December 1938): 279–84.

"Illustrated Books." *The Bulletin of The Metropolitan Museum of Art* 34, 7 (July 1939): 174.

"Print Masterpieces of Five Centuries." *The Bulletin of The Metropolitan Museum of Art* 34, 7 (July 1939): 184–85.

"Daguerreotypes and Photographs." *The Bulletin of The Metropolitan Museum of Art* 34, 11 (November 1939): 240–43.

"Photography's Early Days." *Science Digest* 7 (February 1940): 81–84.

"Silhouettes and Profile Portraits." *The Bulletin of The Metropolitan Museum of Art* 35, 3 (March 1940): 50–54.

"Childe Hassam." *The Bulletin of The Metropolitan Museum of Art* 35, 7 (July 1940): 138–39.

"Childe Hassam." *Art Digest* 14 (August 1940): 22.

"Prints of French Châteaux." *The Bulletin of The Metropolitan Museum of Art* 35, 10 (October 1940): 197–200.

"Prints by Living Americans." *The Bulletin of The Metropolitan Museum of Art* 35, 11 (November 1940): 14–20.

"French Fashions." *The Bulletin of The Metropolitan Museum of Art* 36, 2 (February 1941): 40–48.

"Chinoiserie." *The Bulletin of The Metropolitan Museum of Art* 36, 5 (May 1941): 111–14.

"Renaissance Costume Books." *The Bulletin of The Metropolitan Museum of Art* 37, 7 (July 1942): 158–59.

"Rembrandt in Italy." *The Metropolitan Museum of Art Bulletin* n.s. 1, 2 (October 1942): 93–96.

"The Artists for Victory Exhibition." *The Metropolitan Museum of Art Bulletin* n.s. 1, 4 (December 1942): 141–42.

"Carpentry and Candlelight in the Theater." *The Metropolitan Museum of Art Bulletin* n.s. 1, 6 (February 1943): 198–203.

"Queen Elizabeth's Prayers." *The Metropolitan Museum of Art Bulletin* n.s. 1, 8 (April 1943): 237–42.

"Early American Painters in England." *Proceedings of the American Philosophical Society* 87 (July 1943): 105–9.

"Old Calling Cards." *The Metropolitan Museum of Art Bulletin* n.s. 2, 2 (October 1943): 93–98.

"Jefferson's Enjoyment of the Arts." *The Metropolitan Museum of Art Bulletin* n.s. 2, 4 (December 1943): 140–46.

"Photographs by Eakins and Degas." *The Metropolitan Museum of Art Bulletin* n.s. 3, 1 (Summer, 1944): 1–7.

"Old London." *The Metropolitan Museum of Art Bulletin* n.s. 3, 9 (May 1945): 220–23.

"The Bibiena Family." *The Metropolitan Museum of Art Bulletin* n.s. 4, 1 (Summer, 1945): 29–37.

"The Art of the Counter Reformation." *The Metropolitan Museum of Art Bulletin* n.s. 4, 4 (December 1945): 101–5.

"French Renaissance Etchings." *Magazine of Art* 39 (April 1946): 135–37.

"The Photographic Eye." *The Metropolitan Museum of Art Bulletin* n.s. 5, 1 (Summer, 1946): 15–26.

Captions to illustrations of Renaissance prints and drawings in *The Metropolitan Museum of Art Bulletin* n.s. 5, 3 (November 1946): 92–100.

"Goya's Creativeness." *The Metropolitan Museum of Art Bulletin* n.s. 5, 4 (December 1946): 105–9.

"Visions and Visionaries." *The Metropolitan Museum of Art Bulletin* n.s. 5, 6 (February 1947): 157–63.

"Renaissance Prints and Drawings." *Magazine of Art* 40 (March 1947): 107–9.

"Paris in the 1850's: The Theatre of Daumier." *Theatre Arts* 31 (March 1947): 35–38.

"Renaissance Pamphleteers: Savonarola and Luther." *The Metropolitan Museum of Art Bulletin* n.s. 6, 2 (October 1947): 66–72.

"Northern Gothic Prints." *The Metropolitan Museum of Art Bulletin* n.s. 6, 6 (February 1948): 161–65.

"The Greatest Show Down South." *Artnews* 47, 4 (June 1948): 46–61.

"Lithographs." *The Metropolitan Museum of Art Bulletin* n.s. 7, 3 (November 1948): 86–94.

"The First Famous Print." *The New Colophon* 2, pt. 6 (1949): 167–71. (Reprinted with slight revisions in *The Metropolitan Museum of Art Bulletin* n.s. 9, 3, November 1950: 73–76.)

"Italian XVIII Century Book Illustration." *The Metropolitan Museum of Art Bulletin* n.s. 8, 5 (January 1950): 136–44.

"Prints Acquired in 1949." *The Metropolitan Museum of Art Bulletin* n.s. 8, 6 (February 1950): 157–67.

"Change and Permanence in Men's Clothes." *The Metropolitan Museum of Art Bulletin* n.s. 8, 9 (May 1950): 262–69.

"The First Famous Print." *The Metropolitan Museum of Art Bulletin* n.s. 9, 3 (November 1950): 73–76. (Reprinted with slight revisions from *The New Colophon* 2, pt. 6, 1949.)

"Toulouse-Lautrec." *The Metropolitan Museum of Art Bulletin* n.s. 10, 3 (November 1951): 89–95.

"Writing and Painting in China." *Magazine of Art* 45 (February 1952): 75–77.

"The World of Atget." *The Metropolitan Museum of Art Bulletin* n.s. 10, 6 (February 1952): 169–71.

"A Gift of Currier and Ives Lithographs." *The Metropolitan Museum of Art Bulletin* n.s. 10, 9 (May 1952): 241–44.

"Alive, Alive, O." *The Metropolitan Museum of Art Bulletin* n.s. 11, 6 (February 1953): 164–67.

"Savage and Solitary Genius." *Artnews* 52 (September 1953): 22–23.

"A Modern Artist of the Eighteenth Century." *The Metropolitan Museum of Art Bulletin* n.s. 12, 4 (December 1953): 100–104.

"Political Cartoons Today." *Artnews* 53 (October 1954): 48.

"German Mannerist Drawings." *Art Quarterly* 17 (1954): 176–78.

"German Drawing: The Electric Line." *Artnews* 54 (October 1955): 18–21.

"Two Hogarth Drawings." *The Burlington Magazine* 97 (1955): 256.

"Goya's 'Hannibal Crossing the Alps.' " *The Burlington Magazine* 97 (1955): 295–96.

"The Theater in France." *The Metropolitan Museum of Art Bulletin* n.s. 14, 2 (October 1955): 48–53.

"Two Piranesi Drawings from the Gilmor Collection." *Baltimore Museum of Art News* 20 (October 1956): 1–2.

"Great Prints Are Rare." *Artnews* 56 (November 1956): 22–25.

"Children Are What We Make Them." *The Metropolitan Museum of Art Bulletin* n.s. 15, 7 (March 1957): 181–88.

"The Gifts That Made the Museum." *The Metropolitan Museum of Art Bulletin* n.s. 16, 3 (November 1957): 85–107.

"Budapest: Great Drawings from Noble Collections." *Artnews* 58, 2 (April 1958): 32 ff.

"A Bequest of Prints by Callot and Daumier." *The Metropolitan Museum of Art Bulletin* n.s. 17, 1 (Summer, 1958): 8–18.

"First Victorian Photographer." *The Metropolitan Museum of Art Bulletin* n.s. 17, 4 (December 1958): 113–19.

"Masters with Sealegs." *Artnews* 58 (February 1959): 43 ff.

"German Drawings in Madrid." *Art Quarterly* 23 (1960): 162–68. (Reply by E. Schilling with rejoinder. *Art Quarterly* 26, 1963: 136–38.)

"The Greeks Had No Word for It." *Saturday Review* 43 (May 28, 1960): 38–40.

"Prints Recently Acquired." *The Metropolitan Museum of Art Bulletin* n.s. 18, 10 (June 1960): 325–33.

"The Fountain of Delight." *Artnews* 59 (September 1960): 38–39.

"Stamps Designed by Fine Artists." *Art in America* 49 (1961): 33–39. (Reprinted in *Art in America : What Is American in American Art?* Ed. by Jean Lipman. New York: McGraw Hill, 1963.)

"J. J. Audubon (1785–1851): Draughtsman of the Birds of America." *Graphis* 17 (January–February 1961): 68–73.

"Italian Prints." *The Metropolitan Museum of Art Bulletin* n.s. 19, 7 (March 1961): 206–8.

"Brush and Camera." *Saturday Review* 44 (June 17, 1961): 48–49.

"The Etchings of Jacques Callot." *The Massachusetts Review* 3, 1 (Autumn, 1961).

"Goya." *WMFT Perspective* 10 (October 1961).

"Rowlandson's England." *The Metropolitan Museum of Art Bulletin* n.s. 20, 6 (February 1962): 185–201.

"Pen, Brush, Paper, and Genius." *Saturday Review* 45 (November 1962): 44–45.

"Art of Photography." *Aperture* 10, 2 (1962): 55.

"William Mills Ivins, Jr., 1881–1961." *The Metropolitan Museum of Art Bulletin* n.s. 21, 6 (February 1963): 193–201.

"The Italian Sources of European Stage Design." *Bulletin of the Minneapolis Institute of Arts* 52 (March 1963): 2–13.

"Painters' Playing Cards." *Art in America* 51 (April 1963): 39–42. (Reprinted in *Art in America : What Is American in American Art?* Ed. by Jean Lipman. New York: McGraw Hill, 1963.)

"Matters of Opinion." *Saturday Review* 46 (May 18, 1963): 41–54.

"Velasquez Monument." *Artnews* 62 (October 1963): 43.

"Accidents are Inartistic." *Nation* 197 (November 30, 1963): 370–71.

"Does Your Art Collection Express Your Community?" *American Federation of Arts Quarterly* 1, 3 (1963): 85–92.

"Notes" (on a recent acquisitions show). *The Metropolitan Museum of Art Bulletin* n.s. 22, 5 (January 1964): 184.

"Artists as Anatomists." *The Metropolitan Museum of Art Bulletin* n.s. 22, 6 (February 1964): 201–10.

"How to Bake an Exhibition." *Photography in the Fine Arts Bulletin* (Fall, 1964): 3–10.

"Prints in Elizabethan Poetry." *The Metropolitan Museum of Art Bulletin* n.s. 23, 3 (November 1964): 135–38.

"Swiss Behind the Colors." *Nation* 199 (1964): 414–15.

" 'The Met' from the Inside." *The Metropolitan Museum of Art Bulletin* n.s. 24, 1 (Summer, 1965): 29–36.

"Practical Fantasies." *Apollo* 82 (September 1965): 241–46.

"Aquatint Views of Our Infant Cities." *Antiques* 88 (September 1965): 314–18.

"James J. Rorimer (1905–1966)." *The Art Journal* 26 (1966–67): 44.

"Unidentified Ingres Lithograph." *The Burlington Magazine* 109 (October 1967): 583.

"Daumier." *The Print Collector's Newsletter* 1 (March–April 1970): 1–4. (Reprinted, in part, from "A Bequest of Prints by Callot and

Daumier." *The Metropolitan Museum of Art Bulletin* n.s. 17, 1, Summer, 1958: 8–18.)

"The Photographic Eye." *Album* 3 (April 1970): 14.

"In the Beginning." *Album* 4 (1970): 14.

"Prints & People" (selections from the book). *The Metropolitan Museum of Art Bulletin* n.s. 30, 2 (October–November 1971): 92–93.

"Correspondence." *The Print Collector's Newsletter* 2 (November–December 1971): 99–100.

"Prints & People" (selections from the book). *The Metropolitan Museum Journal* 3 (1971): 357–69.

"Four Centuries of Spanish Painting" (collection of the Hispanic Society, New York). *Apollo* n.s. 95 (April 1972): 252–63.

"Rembrandt, from 'Prints & People.' " *The Metropolitan Museum of Art Bulletin* n.s. 30, 5 (April–May 1972): 210–19.

"The Print That Worked a Miracle." *The Print Collector's Newsletter* 4 (November–December 1973): 97.

"Mrs. Gardner Comes to Call." *Isabella Stewart Gardner Museum—Annual Report*, Boston (1973): 40.

"Remembrance of Dealers Past." *Artnews* 73 (October 1974): 35–36.

"Goya at Boston and Ottawa." *The Print Collector's Newsletter* 5 (January–February 1975): 147–48.

"1776—How America Really Looked: Prints." *The American Art Journal* 7, 1 (May 1975): 43–51.

"Mail Orders in the Eighteenth Century." *Antiques* 108 (October 1975): 756–63.

"Hunt for the Fishing Lady." *Antiques* 112 (July 1977): 113.

"A Truth or Two About Art History." *Record of The Art Museum, Princeton University* 36, 1 (1977): 22–24. (Reprinted, with revisions, in *Princeton Alumni Collections, Works on Paper*, The Art Museum, Princeton University, 1981: 23–26.)

"Rembrandt and the Bible." *The Metropolitan Museum of Art Bulletin* n.s. 36, 3 (Winter, 1978–79). (Reprinted as a book by The Metropolitan Museum of Art, 1979.)

"Contemporary Printmaking in Mexico," by Xavier Moyssén, trans. by Victoria S. Galban and A.H.M. *Print Review* 9 (1979): 57–64.

"Prints and People" (selections from the book). *Transaction/Society* 19, 2 (1982). Published posthumously.

ESSAYS, INTRODUCTIONS, AND
FOREWORDS IN BOOKS AND
EXHIBITION CATALOGUES

Life in America : A Special Loan Exhibition of Paintings Held During the Period of the New York World's Fair. Text by A.H.M. and Josephine L. Allen. New York: The Metropolitan Museum of Art, 1939.

Foreword to *Artists for Victory: An Exhibition of Contemporary American Art; A Picture Book of the Prize Winners.* New York: The Metropolitan Museum of Art, 1942.

The Classical Contribution to Western Civilization. A loan exhibition organized and lent by The Metropolitan Museum of Art . . . to the Art Gallery of Toronto. Text by A.H.M. Toronto: Rous and Mann, 1948.

Introduction to *Baroque and Romantic Stage Design.* Ed. by Jànos Scholz. New York: H. Bittner and Company, 1950.

"A Metal Cut Attributed to Francesco Francia." Essay in *Studies in Art and Literature for Belle da Costa Greene.* Ed. by Dorothy E. Miner. Princeton, N.J.: Princeton University Press, [1954]: 197–98.

"La Scenografia Primo del 1700." Essay in *Tempi e Aspetti della Scenografia.* Ed. by Marziano Bernardi. Turin: Edizioni Radio Italiana, 1954.

Preface to Sasowsky, *Reginald Marsh Etchings . . .* New York: Praeger, 1956.

"Frank Lloyd Wright's Drawings." Essay in *Frank Lloyd Wright: Drawings for a Living Architecture.* New York: Horizon Press (for the Bear Run Foundation, Inc., and the Edgar J. Kaufmann Charitable Foundation, Pittsburgh), 1959.

"Harry Twyford Peters: 1881–1948." Essay in *Grolier 75. A Biographical Retrospective to Celebrate the Seventy-Fifth Anniversary of the Grolier Club in New York.* New York: The Grolier Club, 1959.

Foreword to *Dali, A Study on His Art-in-Jewels, the Collection of the Owen Cheatham Foundation.* Comments and captions by the artist. Ed. by Lida Livingston. Greenwich, Conn.: New York Graphic Society, 1959.

Foreword to *John James Audubon, peintre naturaliste américain, 1785–1851*. Paris: Centre culturel américain, Les Presses artistiques, 1960.

"The Flexibility of Drawings." Essay in *Centennial Loan Exhibition: Drawings and Watercolors from Alumnae and Their Families*. Poughkeepsie, N.Y.: Vassar College, 1961.

Preface to *English Publishers in the Graphic Arts, 1599–1700; A Study of the Print-Sellers & Publishers of Engravings, Art & Architectural Manuals, Maps & Copy-books* by Leona Rostenberg. New York: B. Franklin, 1963.

"Stamps Designed by Fine Artists," and "Painters' Playing Cards." Essays in *Art in America: What Is American in American Art?* Ed. by Jean Lipman. New York: McGraw-Hill, 1963. (Reprinted from *Art in America* 49, 1961: 33–39, and *Art in America* 51, 1963: 39–42.)

Introduction to *Architecture and Perspective: Designs Dedicated to His Majesty Charles VI, Holy Roman Emperor* by Giuseppe Galli Bibiena. New York: Dover, [1964]. (Reprint of *Architetture e Prospettive*. Augsburg, 1740.)

"The Italian Sources of European Stage Design." Essay in *Four Centuries of Theater Design: Drawings from the Donald Oenslager Collection*. Exhibition catalogue by Richard P. Wunder. New Haven: Yale University Art Gallery, 1964.

Note to *50 Lithographs* by James N. Rosenberg. New York: Harry N. Abrams, 1964.

Foreword to *Hispanic Furniture from the Fifteenth Through the Eighteenth Centuries* by Grace H. Burr. New York: The Archive Press, 1964.

Foreword to *Mother and Child in Modern Art*. Ed. by Bruce Hooten and Nina N. Kaiden. Commentary by Frances L. Ilg. New York: Duell, Sloan and Pearce, 1964.

Catalogue of paintings, drawings, sculptures, objects, medals, coins, seals, engravings, and etchings in *Builders and Humanists: The Renaissance Popes as Patrons of the Arts*. Exhibition catalogue. Houston: University of St. Thomas, 1966.

"Drawings for Unidentified Book Illustrations by Tiepolo." Essay in *Homage to a Bookman*, written for Hans P. Kraus on his sixtieth birthday, October 12, 1967. Ed. by Hellmut Lehmann-Haupt. Berlin: Mann [1967]: 235–42.

A. HYATT MAYOR

Introduction and essay in *Directory of the J. R. Burdick Collection, Trade and Souvenir Cards and Other Paper Americana in The Metropolitan Museum of Art*. New York: The Metropolitan Museum of Art, n.d.

Essay in *The Sculpture of Gaston Lachaise*, with Hilton Kramer and others. New York: The Eakins Press, 1967. (From *Hound & Horn* 5, 4, July–September 1932.)

Introduction to *A Complete Course of Lithography* by Alois Senefelder (1771–1834), with a supplement of thirty-one plates from the first German and French editions. New York: Da Capo Press (reprint), 1968.

Preface to *Language of the Print: A Selection from the Donald H. Karshan Collection*. Foreword and essay by Richard V. West. Catalogue commentary by Donald H. Karshan. Brunswick, Maine: Bowdoin Museum of Fine Art, 1968.

Preface to *American Printmaking, The First 150 Years*. Foreword by Donald H. Karshan. Introduction by J. William Middendorf II. Text by Wendy J. Shadwell. Washington, D.C.: Smithsonian Institution Press for the Museum of Graphic Art, New York, 1969.

Foreword to *Late Gothic Engravings of Germany and the Netherlands* by Max Lehrs. New York: Dover (reprint), 1969.

Foreword to *The Art of the Playing Card: The Cary Collection*. Exhibition catalogue. New Haven: Yale University Library, 1973.

"Resources of Libraries in New York City." Essay in *Acts*, Seventh International Congress of Bibliophiles, 1971. Ed. by Gabriel Austin. London: Wm. Clowes & Sons, 1974.

"Pictures for Children." Essay in *Contemporary American Illustrators of Children's Books*. Exhibition catalogue compiled by Judy Freeman. New Brunswick, N.J.: Rutgers University Art Gallery, 1974.

Foreword to *Ices Plain and Fancy* by A. B. Marshall. New York: The Metropolitan Museum of Art, 1976.

Foreword to *The Diaries, 1871–1882, of Samuel P. Avery*. New York: Arno Press, 1979.

Introduction to *A Century of American Sculpture: Treasures from Brookgreen Gardens*. New York: Abbeville Press, 1980.

"Berenson's Revised Book on the Drawings of the Florentine Painters." *Magazine of Art* 33 (1940): 236–38.

"Arthur M. Hind, *Early Italian Engraving*." *Gazette des Beaux-Arts* 40 (1952): 209–10.

"The Kremlin," review of *The Kremlin* by David Douglas Duncan. *Nation* 190, 22 (May 28, 1961): 476.

"News from Strawberry Hill," review of *Horace Walpole* by Wilmarth Sheldon Lewis. *Nation* 193, 9 (September 1961): 184.

"Pen, Brush, Paper & Genius," review of *Great Drawings of All Time* by Ira Moskowitz. *Saturday Review* 45, 44 (November 3, 1962): 44.

"*Giacomo Torelli and Baroque Stage Design* by Per Bjurström." *Master Drawings* 1, 1 (Spring, 1963): 49.

"Melchior Lorck at Copenhagen," review of *Melchior Lorck, Drawings from the Evelyn Collection* . . . by Erik Fischer. *Master Drawings* 1, 4 (Winter, 1963): 57.

"Accidents are Inartistic," review of *Apollinaire: Poet Among the Ruins* by Francis Steegmuller. *Nation* 197, 18 (November 30, 1963): 370–71.

"*La Scenografia del '700 e i fratelli Galliari* by Mercedes Viale Ferrero." *Master Drawings* 2, 2 (1964): 173–74.

"*Agostino Mitelli Drawings* by Ebria Feinblatt and *Architectural and Ornament Drawings in the University of Michigan Museum of Art* by Richard P. Wunder." *Master Drawings* 3, 3 (1965): 282–83.

"*Feast and Theatre in Queen Christina's Rome* by Per Bjurström." *Master Drawings* 4, 3 (1966): 304–5.

"Festival Designs by Inigo Jones." *Master Drawings* 5, 2 (1967): 193–94.

"*Hogarth on High Life. The Marriage à la Mode Series from Georg Christian Lichtenberg's Commentaries*, translated and edited by Arthur S. Wensinger with W. B. Coley." *The Print Collector's Newsletter* 1, 3 (July–August 1970): 66.

"*Die Radierungen des Jacques Bellange* by Nicole Walch." *The Print Collector's Newsletter* 2, 6 (January–February 1972): 130–31.

"Dürer, Dürer, Dürer . . . ," a review of twelve books on Albrecht Dürer. *The Print Collector's Newsletter* 3, 4 (September–October 1972): 88–89.

A. HYATT MAYOR

"*Francisco Goya/Drawings/The Complete Albums* by Pierre Gassier." *Master Drawings* 12, 3 (Autumn, 1974): 285–86.

"Printed Matters," a review of six current books on prints. *Artnews* 73 (November 1974): 79–81.

"Books on [Children's] Books," *The Print Collector's Newsletter* 7, 5 (November–December 1976): 152–53.

"*Renaissance Triumphs*, published by Theatrum Orbus Terrarum, Amsterdam, and Johnson Reprint Corp., N.Y., 1975." *The Print Collector's Newsletter* 8, 3 (July–August 1977): 83.

"*Murillo and His Drawings* by Jonathan Brown." *Master Drawings* 15, 2 (Summer, 1977): 184–85.

"*Cries and Itinerant Trades*, by Karen F. Beall." *The Print Collector's Newsletter* 8, 5 (November–December 1977): 150.

"*The Making of the Nuremberg Chronicle* by Adrian Wilson." *The Print Collector's Newsletter* 9, 2 (May–June 1978): 60–61.

"*The Italian Baroque Stage* by Dunbar H. Ogden." *The Print Collector's Newsletter* 10, 1 (March–April 1979): 23–24.

"*Disegni di Giambattista Piranesi* by Alessandro Bettagno." *Master Drawings* 17, 1 (Spring, 1979): 56.

[Ten books on Piranesi]. *The Print Collector's Newsletter* 10, 4 (September–October 1979): 133–35.

"*Michelangelo* by Johannes Wilde." *Renaissance Quarterly* 33, 3 (Autumn, 1980): 448–50. Published posthumously.

HANDBOOKS

The World of Peter Bruegel. Metropolitan Museum of Art Miniatures. New York: Book of the Month Club, [1952].

Goya, 1746–1828. Metropolitan Museum of Art Miniatures. New York: Book of the Month Club, [1953].

Honoré Daumier. Metropolitan Museum of Art Miniatures. New York: Book of the Month Club, [1955].

Impressions of Kabuki. Photographs by Martha Swope. Brooklyn: Dance Perspectives, [1960].

Daumier and Callot. Print Council of America, 1962. (Reprint of "A Bequest of Prints by Callot and Daumier," *The Metropolitan Museum of Art Bulletin* n.s. 17, 1, Summer, 1958: 8–18.)

Prints. The Metropolitan Museum of Art Guide to the Collections. New York: The Metropolitan Museum of Art, 1964.

Fifteenth and Sixteenth Century Drawings. Catalogue of an exhibition of drawings selected by A.H.M. New York: The American Federation of Arts, 1967.

Rembrandt: The Hundred Guilder Print of Christ's Ministry. Eakins Pocket Album I. New York: Eakins Press Foundation, 1975.

Classic Photographs of New York City: Views of Lower Manhattan. Eakins Pocket Album II. New York: Eakins Press Foundation, 1975.

CALENDARS

Portraits and Masks. Calendar for 1962, New York: The Metropolitan Museum of Art, [1961].

Rembrandt: A Hidden World. Calendar for 1963, New York: The Metropolitan Museum of Art, [1962].

Hokusai. Calendar for 1967, New York: The Metropolitan Museum of Art, [1966].

Flowers For All Seasons. Calendar for 1971, New York: The Metropolitan Museum of Art, [1970].

Parlors and Palaces. Calendar for 1972, New York: The Metropolitan Museum of Art, [1971].

Beasts of Earth and Air. Calendar for 1973, New York: The Metropolitan Museum of Art, [1972].

Gardens East and West. Calendar for 1974, New York: The Metropolitan Museum of Art, [1973].

Life in America. Calendar for 1975, New York: The Metropolitan Museum of Art, [1974].

Secret Gardens. Calendar for 1976, New York: The Metropolitan Museum of Art, [1975].

Unforgettable People. Calendar for 1981, New York: The Metropolitan Museum of Art, [1980]. Published posthumously. (Reprinted as an address book by The Metropolitan Museum of Art, 1981.)

A. HYATT MAYOR

ARTICLES ABOUT A. HYATT MAYOR
AND REVIEWS OF HIS BOOKS

Zucker, Paul. Review of *The Bibiena Family* by A.H.M. *Society of Architectural Historians Journal* 5 (1945-46): 47.

"Changes in the Museum Staff." *The Metropolitan Museum of Art Bulletin* n.s. 4, 9 (May 1946): 243.

Southern, Richard. Review of *The Bibiena Family* by A.H.M. *Royal Institute of British Architects Journal* 53 (July 1946): 416.

Neumeyer, Alfred. Review of *The Bibiena Family* by A.H.M. *Journal of Aesthetics and Art Criticism* 5 (September 1946): 71-72.

Review of *The Bibiena Family* by A.H.M. *Gazette des Beaux-Arts* series 6, 32 (November 1947): 188-89.

Laporte, Paul M. Review of *The Bibiena Family* by A.H.M. *College Art Journal* 7, 4 (1948): 336-37.

Rapp, Franz. Review of *The Bibiena Family* by A.H.M. *The Art Bulletin* 33 (December 1951): 285-88.

Hunter, Sam. "Felicitous Accident." Review of *Giovanni Battista Piranesi* by A.H.M. *Art Digest* 27 (April 1953): 22.

Review of *Giovanni Battista Piranesi* by A.H.M. *Artnews* 52 (May 1953): 14.

Stampfle, Felice. Review of *Giovanni Battista Piranesi* by A.H.M. *The Art Bulletin* 35 (June 1953): 159-61.

Tubbs, Grahame B. Review of *Giovanni Battista Piranesi* by A.H.M. *Royal Institute of British Architects Journal* 60 (August 1953): 418.

Warner, Oliver. Review of *Giovanni Battista Piranesi* by A.H.M *Apollo* 58 (December 1953): 200.

Review of *Giovanni Battista Piranesi* by A.H.M. *Art Quarterly* 16, 3 (1953): 273-74.

Review of *Giovanni Battista Piranesi* by A.H.M. *Studio* 147 (January 1954): 32.

"Museum Curator Refuses to 'Rust.'" *The New York Times* (June 19, 1966).

"Address by A. Hyatt Mayor." *Gazette of the Grolier Club* n.s. 9 (February 1969): 12-13.

Canaday, John. "The Way It Happened Was, The Chinese Invented Paper. Then" Review of *Prints & People* by A.H.M. *The New York Times* (December 12, 1971).

Case, W. D. Review of *Prints & People* by A.H.M. *Arts* 46 (February 1972): 21.

Kirstein, Lincoln. Review of *Prints & People* by A.H.M. *Nation* 214 (February 14, 1972): 219.

White, Christopher. "Review of *Prints & People: A Social History of Printed Pictures*, by A. Hyatt Mayor." *The Print Collector's Newsletter* 3, 2 (May–June 1972): 41.

Robison, Andrew. Review of *Prints & People* by A.H.M. *Library Journal* 97 (June 15, 1972): 2177.

Livie, R. B. Review of *Prints & People* by A.H.M. *Pantheon* 30 (July 1972): 350–51.

Thomas, D. Review of *Prints & People* by A.H.M. *Connoisseur* 180 (July 1972): 227.

Kelder, Diane. Review of *Prints & People* by A.H.M. *Art in America* 60 (November 1972): 43–44.

Kirstein, Lincoln. "A. Hyatt Mayor." *Print Review* 6 (1976): 5–11.

Eisler, Colin. "A. Hyatt Mayor, Teacher of Enchantment." *Print Review* 6 (1976): 15–17.

"An Interview with A. Hyatt Mayor," conducted by Paul Cummings. *Archives of American Art Journal* 18, 4 (1978): 2–19.

[Ives, Colta] and Kirstein, Lincoln. *A. Hyatt Mayor, June 28, 1901–February 28, 1980*. New York: The Metropolitan Museum of Art, 1980 (with excerpts from *Print Review* 6, 1976).

Glueck, Grace. "A. Hyatt Mayor, Former Curator of Prints at the Metropolitan, 78." *The New York Times* (March 1, 1980).

"A. Hyatt Mayor, 1901–1980." *Art in America* 68 (April 1980): 176.

Russell, John. "Critic's Guide to the New Print Shows." *The New York Times* (June 13, 1980).

Shaw, James Byam. "Obituary." *The Burlington Magazine* 122 (June 1980): 439.

Clark, Cynthia. "Five American Print Curators." *The Print Collector's Newsletter* 11 (July–August 1980): 88.

Lynes, Russell. "Hyatt Mayor: 'A Cautious, Knowing, Loving Eye.'" *Artnews* (Summer, 1980): 121.

Munhall, Edgar. "Zum Tode von A. Hyatt Mayor." *Du* 7 (1980): 75.

Ives, Colta. Foreword to *Unforgettable People*. Calendar for 1981 by A.H.M. New York: The Metropolitan Museum of Art, [1980].

Composed in English Monotype Ehrhardt and
printed letterpress on Mohawk Vellum Text at
The Press of A. Colish, Mount Vernon, New York.
Binding by Publishers Book Bindery,
Long Island City, New York.

First printing, 1983: 2,000 copies